Leica M digital photography

Leica M digital photography M8 / M8.2

Brian Bower

LARK BOOKS

A Division of Sterling Publishing Co., Inc.
New York / London

Editor: Frank Gallaugher
Book Design and Layout: Tom Metcalf
Cover Design: Thom Gaines

Library of Congress Cataloging-in-Publication Data

Bower, Brian.
 Leica M digital photography : M8/M8.2 / Brian Bower. — 1st ed.
 p. cm.
 Includes bibliographical references and index.
 ISBN 978-1-60059-193-8 (pb-pbk. with deluxe flaps : alk. paper)
 1. Photography—Digital techniques. 2. Leica digital cameras. I. Title.
 TR263.L4B6375 2009
 775—dc22

 2008050898

10 9 8 7 6 5 4 3 2 1

First Edition

Published by Lark Books, A Division of
Sterling Publishing Co., Inc.
387 Park Avenue South, New York, N.Y. 10016

Text © 2009, Brian Bower
Photography © 2009, Brian Bower unless otherwise specified

Distributed in Canada by Sterling Publishing,
c/o Canadian Manda Group, 165 Dufferin Street
Toronto, Ontario, Canada M6K 3H6

Distributed in the United Kingdom by GMC Distribution Services,
Castle Place, 166 High Street, Lewes, East Sussex, England BN7 1XU

Distributed in Australia by Capricorn Link (Australia) Pty Ltd.,
P.O. Box 704, Windsor, NSW 2756 Australia

This book is not sponsored by Leica Camera AG.

If you have questions or comments about this book, please contact:
Lark Books
67 Broadway
Asheville, NC 28801
(828) 253-0467
www.larkbooks.com/digital

Manufactured in China

ISBN 13: 978-1-60059-193-8

For information about custom editions, special sales, premium and corporate purchases, please contact Sterling Special Sales
Department at 800-805-5489 or specialsales@sterlingpub.com.

Acknowledgements

Again, I can only marvel at the help and understanding of my wife Valerie while I have been working on this book. She has tolerated my long time obsession of all things Leica, been patient during my "away" days when my mind has been totally absorbed with writing or researching, and always been prepared to give me maximum help with word processing, editing, and proofreading the text.

I am grateful also to all the friends and fellow photographers, too numerous to mention individually, who have helped and humored my enthusiasms. Their encouragement has been greatly valued. I should mention also the many members of the Leica Historical Society of America and the Leica Forum. The meetings and the excellent magazine of the former, together with the web postings of the latter, have been not only important sources of information but also inspiration. The depth of knowledge freely available from so many fellow enthusiasts frequently humbles me.

The Leica organization has always given me unhesitating cooperation and assistance. In connection with this book I would especially like to thank Stefan Daniel of Leica Germany and Nobby Clark of Leica UK for their continuing help and encouragement. At Lark Books my special thanks go to Marti Saltzman, the Editorial Director who has supported and advised me on this project through a number of changes in concept that have been necessary as Leica's digital program has evolved. Although Marti has been my main point of contact I am also truly appreciative of the entire team at Lark—editorial, design, production, and marketing—all of whose skills and effort are so essential to the success of a book.

Brian Bower

Cheshire, England

October 2008

contents

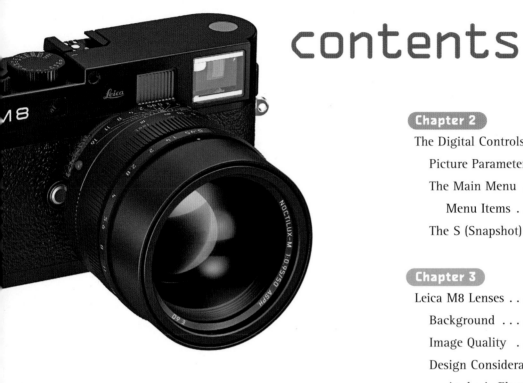

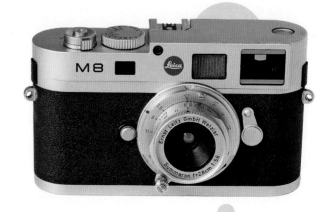

introduction

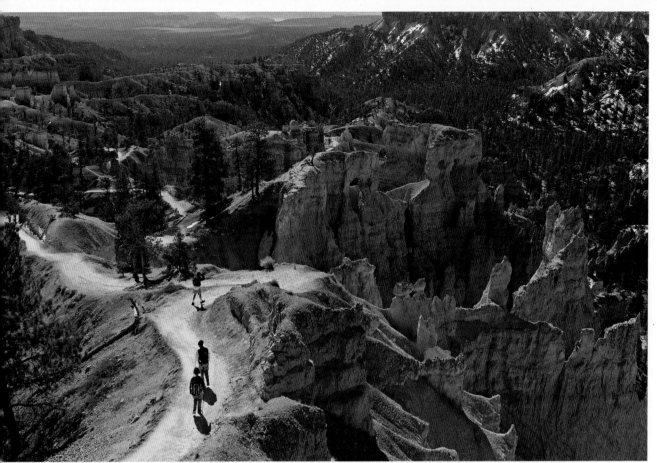

arly morning at Bryce Canyon. Everything was still, the air was like wine and the light was wonderful. A group of ackpackers appeared in just the right place and the M8 was the perfect camera to capture the moment. The lens was e 28-35-50 Tri Elmar ASPH at 28mm.

The Rangefinder Style

omebody once called the camera a time machine—a evice that captures a moment, an instant. I like this oncept. While there is absolutely no doubt that a cam- ra can be used as a creative tool, I have always felt that apturing the moment, the reality, is what it does best.

his particular ability is the great strength of the angefinder camera, most especially the highly volved Leica M. The rangefinder style truly is dif- erent. The photographer is more directly involved ith his subject; he is merely putting a frame around hat he is seeing. The camera is much more an xtension of his mind and his eye that can seize and cord a moment. And if he is good it can even be a ecisive moment" as that most famous of Leica pho- graphers, Henri Cartier Bresson, called it!

With a reflex camera a more considered approach is natural. The image is precisely framed and carefully composed on a focusing screen. The photographer is slightly remote, a step removed from reality. He is observing events in two dimensions almost like watch- ing a television screen. Parts of the subject are in focus and parts are out of focus. Although when stopped down this has the advantage of showing how the pho- tographic image will eventually appear, this is not like the human eye, which is constantly scanning and refo- cusing and is aware of elements of the whole scene.

It is no surprise that the Leica M is a preferred tool of many street photographers and photojournalists. In accordance with the rangefinder style described above, it is relatively small, discreet, and quiet. It is the per-

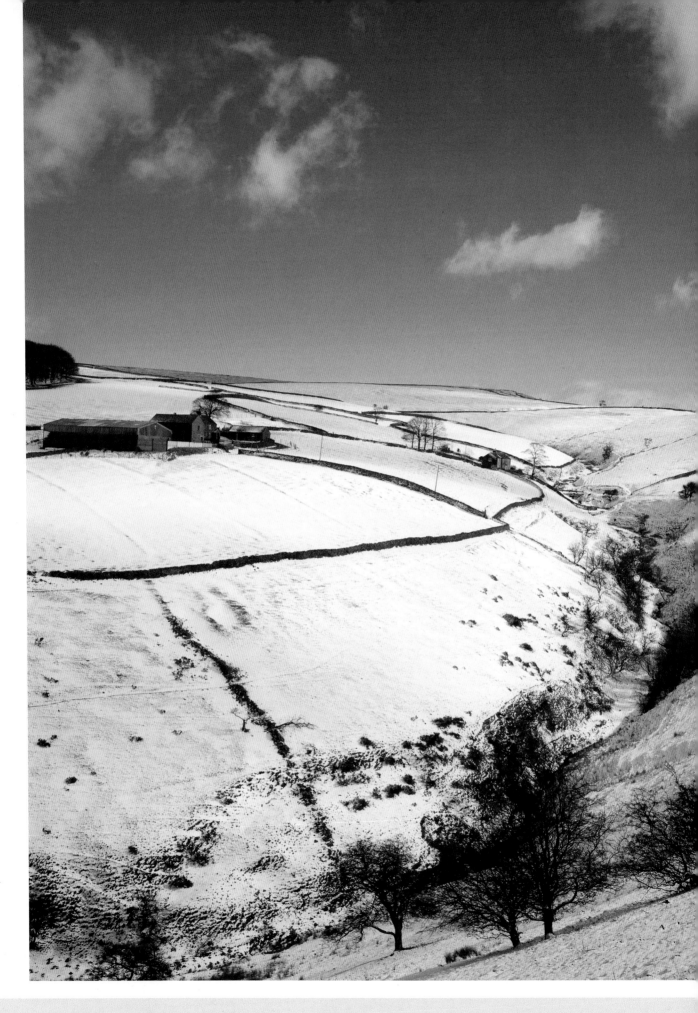

ct instrument for use with wide-angle lenses—closer to the action again! It has the essential attributes for lowlight photography, some outstanding high speed lenses, and a very positive focusing system ideally suited to such situations.

On a more general note the M is ergonomically near-perfect. The basic design started out right and it has been honed and refined over a period of more than fifty years. It is a photographic icon; it is a lovely precision instrument; and it is elegant. Simple and straightforward to operate, it is a real photographer's camera with a purist concentration on essentials and a continuing pleasure to use.

However—the Leica M does have limitations! It certainly demands more from photographers in terms of visualization and technique, but it also puts them more in control. It is not a camera for regular long lens or close-up photography. This is where the single lens reflex does show its strengths.

The first Leica I ever used was an M2. At that time I was using a Pentax SLR and my uncle, who had an M2, suggested that we exchange outfits for a month. The Pentax was a very good camera, but the Leica together with its lenses was a revelation. At last I understood what all the fuss was about! The Leica went back to my uncle and within a month I had sold the Pentax, found an ex-demo M2 languishing on a dealer's shelf, and acquired 35, 50, and 90mm lenses. I just could not put the camera down and the fact that I had absolutely no excuses on the equipment front encouraged a serious improvement in my photography. Since that M2 I have at some time or other been lucky enough to own and thoroughly enjoy using all the subsequent Leica M models. However, none of them has engendered quite the same excitement and "can't put it down" effect as that first M2.

Peak District Farm in Winter. Snow shots require careful exposure in order to achieve correct tonal values in the white areas. 28mm Summicron-M ASPH

That is until the M8 came along. Once the digital revolution was clearly the future, a good many M users began to badger Leica for a digital version of their favorite camera. Leica, quite correctly, thought that it was essential to stay within the parameters of the existing body shape and size in order to retain the style and proven ergonomics. It was also felt to be very important to maintain the maximum possible lens compatibility and not to compromise image quality in any way. There were many technical problems to overcome, but persistence together with developing technologies has enabled this to be achieved with relatively little compromise. The Leica M philosophy of concentration on essentials has been maintained within the digital elements of the design.

The M8 has given me just the same pleasure and desire to take photographs as did my M2. It is a wonderful camera that produces images of exceptional quality and is an absolute delight to use. As I am writing this I have been using an M8 for over two years and I am still looking for every excuse to get it out of the gadget bag and make pictures.

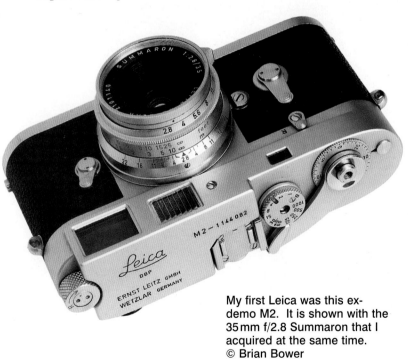

My first Leica was this ex-demo M2. It is shown with the 35mm f/2.8 Summaron that I acquired at the same time.
© Brian Bower

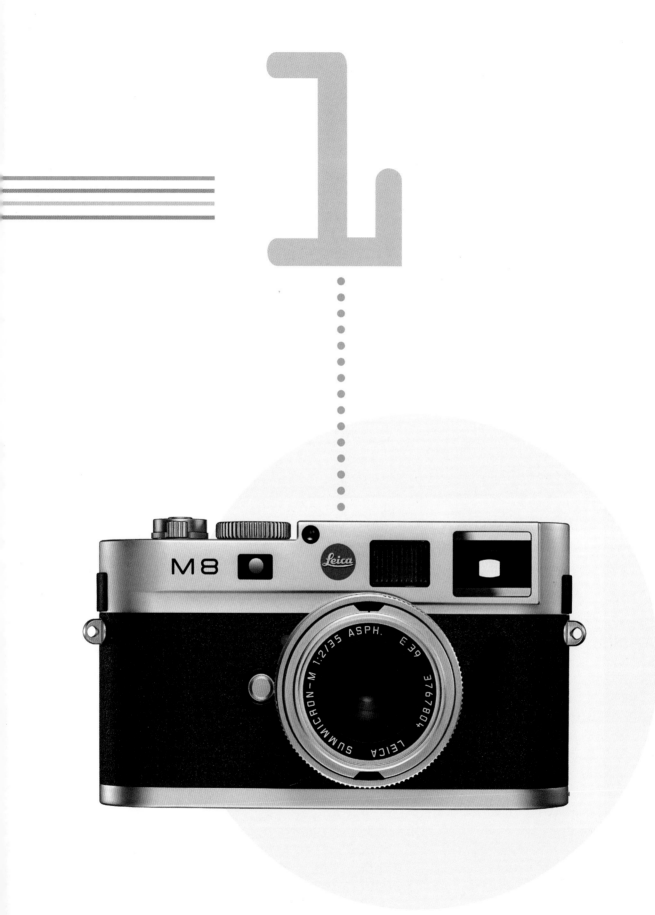

The Leica M8 and M8.2

The Leica M3 was the first camera in Leica's iconic 'M' line. It featured viewing frames for 50, 90 and 135mm lenses and is shown here with the classic 'rigid chrome mount' Summicron 50mm.
© Brian Bower

The Background

The M8 and the M8.2 have pedigree. They are the latest in the line of Leica cameras that started in 1954 with the M3. This camera was a major step forward from the screw mount rangefinder cameras with which Leica had pioneered 35mm photography and the concept of a system camera—i.e., one with interchangeable lenses and accessories for a variety of applications, telephoto, close-up, copying, micro photography, etc. The M3 was followed in 1958 by the M2. This camera started as a cheaper alternative but the redesigned range/viewfinder that enabled the use of a wide-angle 35mm focal length without an accessory finder was the critical design change. There were a few cosmetic changes but, in every other respect, the M2 body was identical in size, shape, and handling to the M3.

Because the wide-angle style facilitated by the new viewfinder fulfilled perfectly the needs of many leading photojournalists and documentary photographers, such that the M2 eventually became the preferred model. As a result, the M2 became the basis for the long-term development of the M series via the M4, M4-2, M4P, and the M6 up to the current M7 and MP film models.

The Leica M has become an icon. Its perfected handling, precision focusing, robust construction, and the range of lenses that has been regularly updated to maintain optical and mechanical superiority have made it a legend. Occasionally, this has presented problems for Leica. With the M5, a completely different body was introduced in order to accommodate through-the-lens metering. This new body shape was not a success—somehow, it lacked the wonderful ergonomics of the earlier shape—so new variants of the M4 (the M4-2 and M4P) were produced continuing the classic style and perfected handling of the previous M cameras.

Basic Camera Features

Ever since the adverse reaction to the M5, Leica has been very careful to stay close to the original body size, shape, and appearance. This together with the need to maintain compatibility with the earlier M lenses, presented a real challenge when developing a digital body for the M system. When compared with the current M7 film model, the M8 and M8.2 digital bodies can really only be easily distinguished by the lack of a wind-on lever and rewind button on the top plate. The feel, the weight, and the handling of the new camera are so similar that it is sometimes difficult to remember whether it is a film body or the digital M8—particularly as the viewfinder display is very similar to that of the M7.

Although it is not apparent without a direct comparison, the M8/8.2 body is 0.125 inch (3 mm) deeper than the predecessor M7. Given the requirement to incorporate all the electronics, the battery, the SD card for recording images, and the image viewing screen on the rear of the camera, it is remarkable that everything has been fitted into such a compact body. Just as remarkable is the almost complete compatibility that has been maintained with the lenses and accessories of the current film-based Leica M cameras. The very great majority of older M lenses can also be used along with many interesting discontinued accessories.

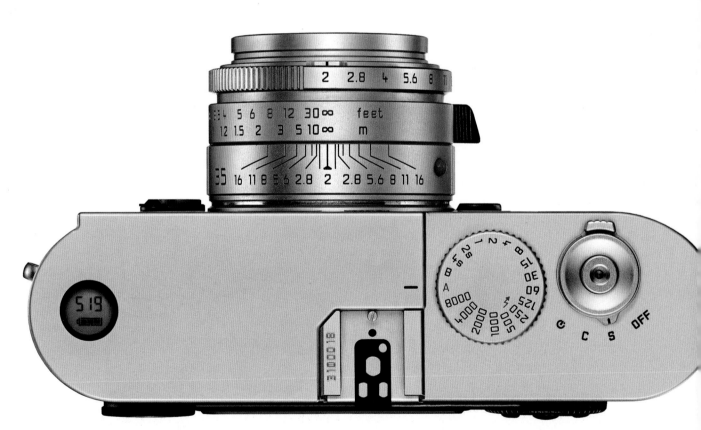

The top plate of the M8 showing the on/off shutter speed dial switch with settings for single shot, continuous and delayed action. The counter on the left indicates the number of shots still available and the battery charge level.

The Shutter

There is a new multi-blade, vertical running shutter similar to that found in the Leica R9/R8 replacing the horizontal-running, rubberized fabric, focal plane shutter. The new shutter provides a wider range of shutter speeds than did the old one. Using a conventional dial on the top of the body, you can manually set these in half steps from 4 seconds to 1/8000 second. When the dial is set to Auto (aperture priority only) the available shutter speeds run from 32 seconds to 1/8000 second. In Auto mode, the shutter speed set by the camera is displayed in the viewfinder to the nearest 1/2 step increment, although the speeds are really set in 1/10 step increments. All of this new technology has also made it possible to increase the flash synchronization speed from 1/50 second to 1/250 second (1/180 in the M8.2), which is especially useful when using fill flash in daylight.

The small lever below the shutter speed dial switches the camera on/off, and there are three settings for single-shot mode, continuous shooting, and delayed action (self-timer). Continuous shooting is 2 fps (frames per second), up to a maximum of 10 RAW images before the buffer is full and the images are downloaded to the SD card. The self-timer can be set for a delay of 2 or 12 seconds via the Main Menu.

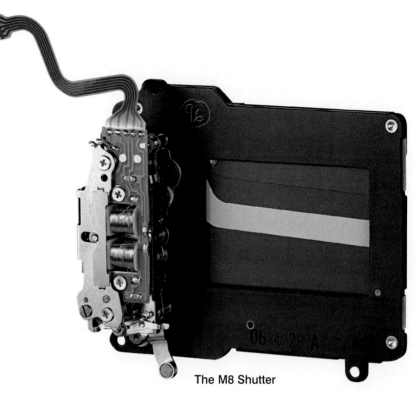
The M8 Shutter

Long term compatibility, the M8 is shown with a 28 mm Summicron. This is a screw mount lens from 1950, used with a screw to bayonet adapter.
© Brian Bower

Metering

The TTL metering sensors now read from a horizontal white strip (one of the shutter blades) rather than a white spot, and the metering cells are in the base of the body rather than in a top corner. Although the metering area is horizontal, it is quite well center-weighted and provides very accurate exposures even in the most difficult situations—especially when combined with reasonable photographic skill. There are three metering cells: a central one for ambient light metering and two outer ones for TTL flash metering.

TTL flash metering is achieved via a short preflash that is activated immediately before the picture is taken. This is achieved with either Leica's own SF24D flash unit or flash units compatible with the Metz SCA 3502 module (from version M4).

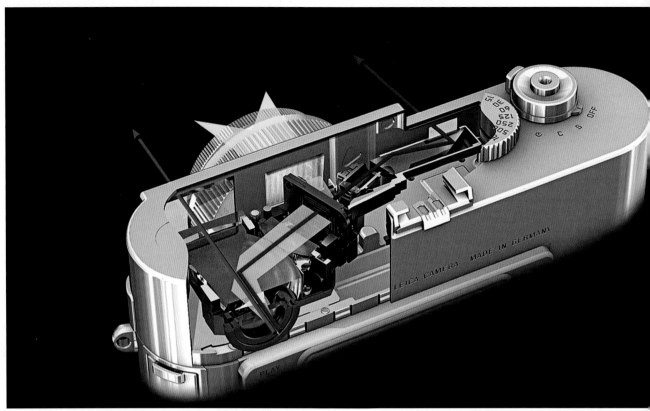

A cutaway of the M8 Range-Viewfinder. This is a jewel of precision mechanical and optical design and engineering.

Range/Viewfinder

The range/viewfinder is the well-proven, highly developed M system pattern with a base length of 2.7 inches (69.25 mm) and combined split-image/coincident-image focusing. This makes it precise and clear, with great accuracy that is independent of the focal length of the lens. The magnification has been slightly reduced from the standard 0.72x to 0.68x. When a lens is fitted, the appropriate pair of luminous brightline frames appears automatically in the viewfinder. In order to facilitate lens selection, it is possible to preview each pair by moving the small lever on the front of the camera just below the viewfinder window. This falls naturally to the left index finger when you're holding the camera. The frames move downward and to the right as you focus from infinity to the near range, in order to compensate for parallax error between the lens and viewfinder axes.

The brightline frame viewing angles have been adjusted for the reduced size of the CCD sensor compared with the 36×24mm film frame. The frames now correspond to 37 and 120mm (with 28 and 90mm lenses), 66 and 100mm (with 50 and 75mm lenses), and 32 and 47mm (with 24 and 35mm lenses). There is no longer a brightline frame for the 135mm lens because it would be equivalent to 180mm. With the lower viewfinder magnification and the very small brightline frame that would be needed, both framing and focusing accuracy were considered to be insufficiently accurate for this lens.

Viewfinder Information

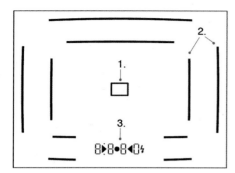

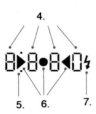

The viewfinder display.

1. Rangefinder image field

2. Brightline frames for 24mm and 35mm lenses

3. Four-digit LED display

4. Automatically-determined exposure time in aperture priority A

 Countdown of exposure times for speeds longer than 1 second

 Exposure compensation value

 Warning that the buffer memory is temporarily full

5. Upper red dot lights to show that saved metering values are being used

 Lower red dot flashes to show that exposure compensation is being used

6. In the Manual and S (snapshot) modes the left and right triangles indicate possible under- or overexposure, respectively. Center circle indicates correct exposure

 Warning of values below the metering range

7. Flash readiness

 Adequate Flash illumination

iewfinder Information

addition to the brightline frames for the different nses and the readout of the shutter speed that is set hen in Auto mode, the viewfinder contains three further displays: Metering information to enable correct posure when setting shutter speeds in manual mode sh-ready and flash-satisfactory symbols when a suitly compatible flashgun is in use (see chapter 7) and o small dots. The upper dot lights up to indicate hen the autoexposure (AE) lock is in use. If the lower t is illuminated, it is a warning that some degree of posure correction has been set.

The manual metering information consists of a red dot with two red arrows, one on each side. Correct exposure is indicated when only the red dot is showing. When one of the arrows appears, either the lens aperture ring or the shutter speed dial needs to be rotated in the direction indicated by the arrow. If an arrow and the dot are showing at the same time, the exposure is over or under by a half stop. If metering is out of range due to insufficient light or too small an aperture setting, the left arrow will flash. In Auto mode, when the meter is out of range, the indicated shutter speed will flash.

Lens Mount

The lens mount is the standard M bayonet fitting that was introduced in 1954 with the Leica M3. With very few limitations (see chapter 4), almost every Leica M lens produced since then (as well as most accessories) will fit. All current production Leica M lenses are 6-bit coded on the lens mount in order to identify the lens and transmit information such as focal length and maximum aperture to the processor. This information is combined with the other information for each shot (shutter speed, ISO, white balance, etc.) and included with the EXIF data within each image file. The information identifying the lens and its focal length enables the camera firmware to compensate for the vignetting characteristics of particular lenses. In addition, when the appropriate setting is chosen in the Main Menu, this information is used to set the lowest shutter speed possible, while avoiding camera shake with that particular lens; and it will adjust the flash head setting on compatible flashguns. Many earlier lenses can be retrofitted with a new bayonet mount incorporating appropriate coding, but there is also a menu function that allows the camera to be used without coded lenses.

Locations of the Digital Controls

On the back of the camera, there is a large, bright (2.5 inch) color monitor, six buttons, and a setting ring for controlling digital operations and menus. In keeping with the M principle, these have been kept very simple and straightforward with all of the essential picture taking controls quickly available without scrolling through multiple menus. (See Chapter 2.)

The battery and the SD card are accessed via the traditional Leica M removable base plate. One useful change is that the tripod mount has been centrally located, rather than at the end of the base.

The 6-bit lens coding is a combination of black and white dots unique to each lens. It provides EXIF data and information for the camera's firmware to optimise processing of the image data.

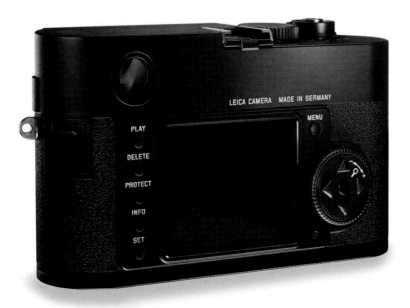

On the back of the Leica M8 and M8.2 are the viewing screen and the various digital controls.

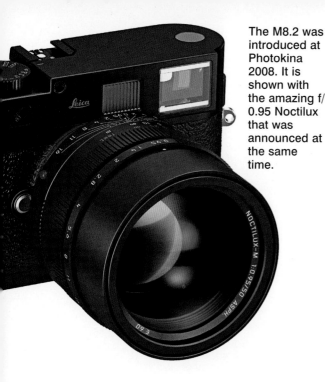

The M8.2 was introduced at Photokina 2008. It is shown with the amazing f/0.95 Noctilux that was announced at the same time.

The M8.2

This model was announced at Photokina 2008. As the name suggests, it is an updated version of the M8. As well as various internal refinements that were incorporated as production of the original M8 progressed, there are a number of new features resulting from both experience and feedback on the M8, and there is an extra mode to simplify operation of the camera for less experienced users if they wish.

The Rangefinder

As previously explained, on the M8, the brightline frames for each focal length show the field of view at the closest focusing distance. When a lens is focused at greater distances, the field of view widens and more is included in the picture taken than is shown in the viewfinder. This can be somewhat disconcerting and Leica has now reverted to their viewfinder design from the earlier M cameras and set the frame sizes for the slightly greater distance of 6.6 feet (2m). Most of the time this is a more useful compromise, but it does mean that when working at the closer distances with critical subjects, it is worth checking the viewing screen to be sure that the image framing is correct. The new viewfinder frames can be retrofitted to M8 cameras.

The Shutter

The revised shutter that was first announced early in 2008 as an after-sale upgrade option for the M8 is a standard feature on the M8.2. The travel speed of the shutter blades has been reduced, resulting in lower inertial forces, and consequently, in smoother and quieter overall operation and less possibility of shutter-induced shake. The downside is that the top shutter speed is now 1/4000 second instead of 1/8000 second and the highest flash synchronization speed is reduced from 1/250 second to 1/180 second. The M8.2 also features a menu-selectable option to delay the motorized shutter wind so as to provide an opportunity to muffle the resulting noise. And yet another refinement is that exposure compensation settings can be made by holding the release button at the first pressure point and making the required correction with the dial on the back of the camera.

The S Setting

There are many people who appreciate the iconic Leica M for the rangefinder style and the quality of image and build, but who have neither the time nor the inclination to acquire the essential technical knowledge to get the very best from it. They just want the superior images! For such users, the S setting simplifies operation of the camera so that concentration can be directed at picture visualization. In this mode, the camera controls all the key features with autoexposure, auto white balance, and auto resetting of ISO if necessary. Pressing the INFO button displays advise on the LCD screen regarding aperture and focus settings for the three most commonly used subject modes. The relevant depth of field for the particular lens in use is also shown. Note, however, that this feature is effective only with 6-bit coded lenses and lenses of 35mm or shorter focal length.

Automatic resetting of the ISO is also available in Manual or Auto modes on the M8.2. From firmware 2.00 this facility can be enabled on the M8 as well.

General

More new features on the M8.2 include:

• An extra hard, sapphire glass, scratchproof viewing screen. This was an after-sale option for the M8 and is now standard on the M8.2.

• The on/off switch features a more pronounced détente to prevent inadvertent engagement of the delayed action setting.

• The black finish is now a high-quality, durable black paint and the body covering is made of especially robust vulcanite.

• And finally, in order to make the black finish model even less conspicuous, the Leica dot and the accessory shoe are black, and blend in with the color of the camera.

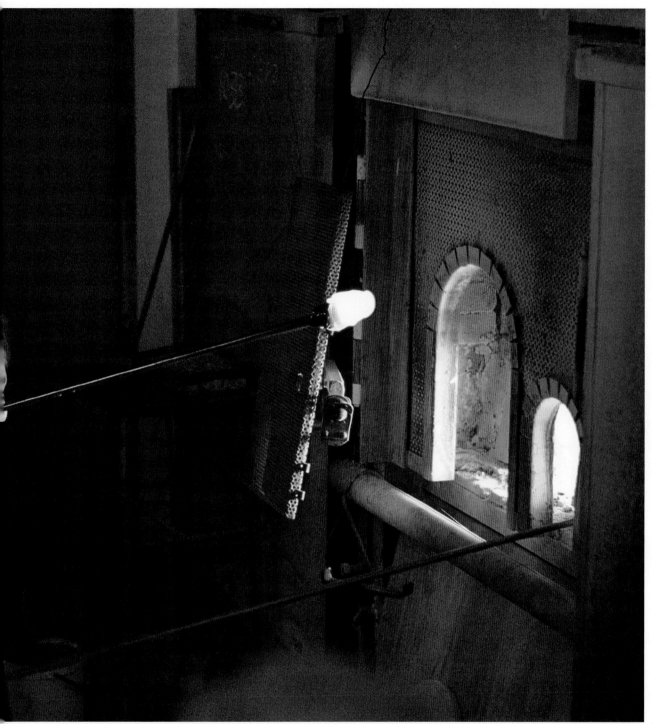

Murano glass blower. The light was very poor and I had to use the 50mm Summilux ASPH at f/1.4 and ISO 2500.

The Digital Controls

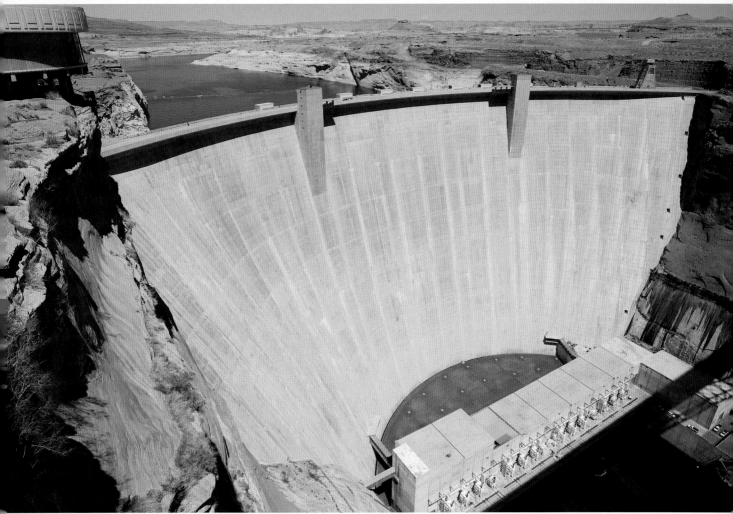

...en Canyon Dam. This shot was taken from the bridge and it was just possible to include the whole structure by using ...e 16-18-21mm Tri-Elmar-M ASPH set to 16mm.

As previously mentioned, the controls for the Leica M8's digital functions have been kept as simple and straightforward as possible. This is keeping with the Leica philosophy of concentrat...g on the essentials for a serious photographer ...hose concern is with control and with capturing the ...ages that he visualizes.

All the controls are on the back of the camera: The familiar four-way controller with touch keys for up/down and left/right scrolling through menus, an outer control dial that can also be used for up/down scrolling as well as a number of other functions, and six dedicated buttons: MENU, PLAY, DELETE, PROTECT, INFO, and SET. The five buttons to the left of the viewing screen on the back of the camera are for the most frequently needed functions. Leica calls these the Picture Parameters.

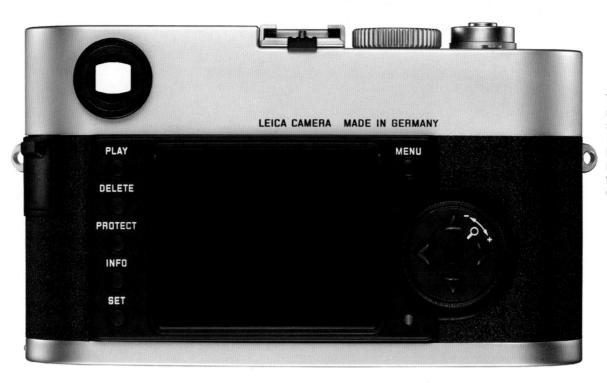

The back of the M8 showing the LCD screen, the five Picture Parameter buttons, the MENU button, and the four way controller with outer dial control.

Picture Parameters

PLAY Pressing this button allows the pictures that have been taken to be reviewed on the screen. The left/right touch keys on the four-way controller move to the previous or following image. The dial control magnifies the image when rotated clockwise and the area viewed can be moved left and right or up and down using the touch keys. Rotating the dial counter-clockwise reduces the magnification; further rotation after the full image is on the screen will show the current image with up to three others; and with still further rotation, the screen displays up to eight others.

When you are viewing a magnified or reduced image, pressing the PLAY button returns to the full picture. When viewing the full image, pressing the PLAY button switches off the screen. Remember that in PLAY mode, there is continuing battery power consumption, and frequent "chimping" to check the images will make it necessary to recharge your batteries more often.

DELETE: When an image is being viewed on the screen, pressing this button brings up two options: [Single] and [All]. Choose the appropriate function and press the SET button to delete the image if you've chosen [Single]. If you've selected [All], a further warning message will appear.

My practice is only ever to delete single images with this function in order to avoid any possible danger of accidentally deleting a whole memory card. To clear a whole card, I generally use the [Format SD Card] function in the Main Menu after downloading images successfully onto my computer. I do not use the computer function for clearing a card after downloading.

PROTECT: Images can be protected from accidental deletion by pressing this button and then selecting [Single] or [All] with the controller keys. A protected image is indicated by a key symbol in the bar across the top of the screen. Images can be unprotected using the same function button. Be warned, however, that using the [Format SD Card] function will still delete protected images.

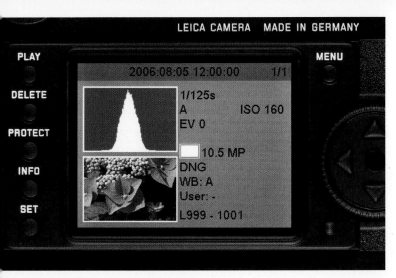

The picture display with the histogram.

INFO: Press this button when reviewing a picture to show a reduced-size image together with a histogram showing the distribution of tonal values within the image. The histogram counts the pixels in each tone reading from the darkest on the left to lightest on the right. A correctly exposed image will normally show a majority of tonal values in the center two thirds of the histogram with no bunching too far to the left or right. (See also Chapter 10.)

Within the Main Menu, the format of the histogram can be changed to show an overall distribution of tones in a black and white format or that of the three primary colors (Red, Green, and Blue) with or without clipping. If [with clipping] is chosen, the histogram will show a red line when the exposure at the highlight end has exceeded the dynamic range of the sensor. Overexposed areas of the image will also be shown red.

The histogram within the viewing screen is rather small for any detailed analysis so that [with clipping] is probably the most useful for a quick check that can be a handy guide at the time of taking. This is often helpful with a particularly tricky exposure. As well as the reduced image and the histogram, some of the EXIF data recorded with the picture is shown: date and time, shutter speed, ISO speed, any Ev adjustment, compression format, white balance, the image file reference, and the lens used if 6-bit coding is activated. Sections of the image can still be magnified using the control wheel so that selected areas can be assessed with the histogram.

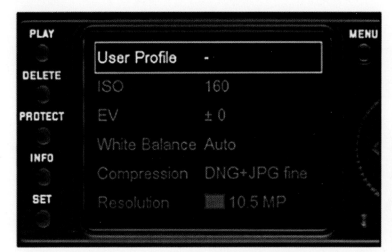

The various functions that are controlled with the SET button.

SET: This button has a number of functions. It is used in conjunction with other buttons and items within the Main Menu. It also brings up its own menu of the most important parameter settings when the camera is in its shooting mode. These are [ISO], [EV], [White Balance], [Compression], [Resolution], and [User Profile].

Scrolling down to each of these items and then again pressing SET brings up a sub-menu. Scrolling with the four-way controller again selects the required item, which is highlighted and then selected by again pressing SET. A further sub-menu then appears which can be scrolled through with the control dial or the four-way controller. You can now scroll to any other item on the SET menu or accept the overall settings by pressing the shutter release.

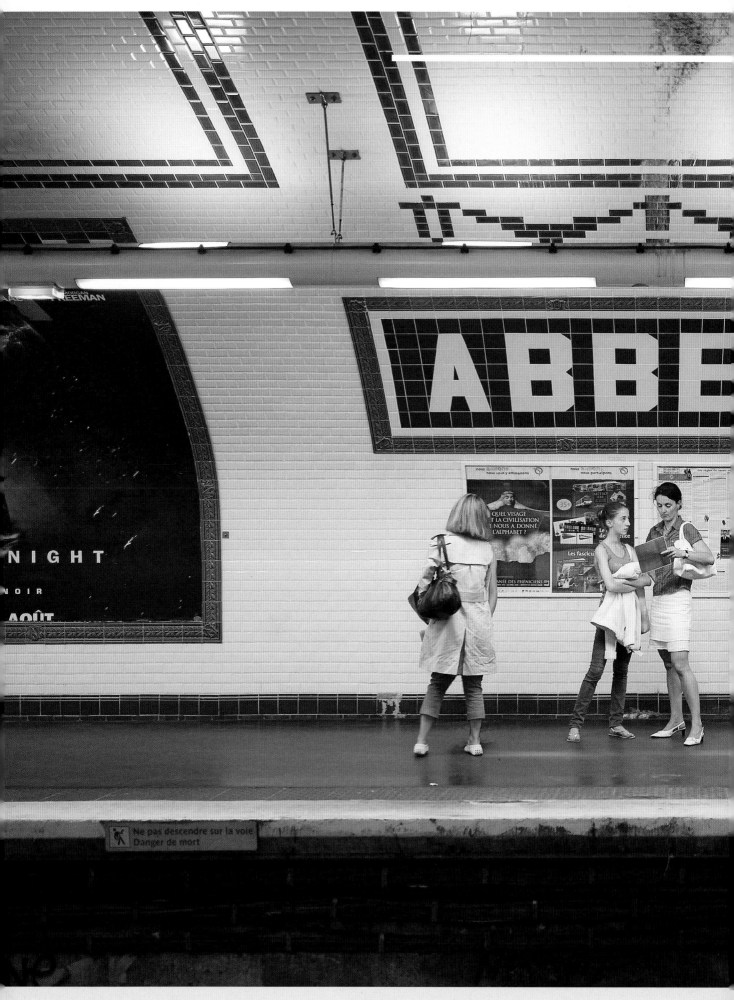

On the Paris Metro. The camera was set to Auto Exposure and Auto White Balance. This image was from a DNG file and hardly any adjustment was needed. 28mm Summicron ASPH at f/2.

Menu item	Sub-Menu
ISO	AUTO ISO (activates the settings made in the Main Menu with AUTO ISO Setup) 160 320 640 1250 2500
EV	After pressing SET again, use the four-way controller or the control dial to scroll to +/- adjustments in 1/3 EV increments to a maximum of +/-3 EV.
White Balance If you are shooting DNG it is easy to carry out any desired adjustment when downloading images to the computer. It may sometimes be convenient to use one of the presets but do not forget to reset if you are working in different light.	**Auto (generally very reliable from firmware version 1.201)** Tungsten Florescent Daylight Electronic Flash Cloudy
Compression Because JPEG images are immediately usable without further conversion or post processing, my standard practice is to shoot DNG + JPEG fine. This gives me a useful option at a later stage after the images have been transferred to my computer.	**DNG (for maximum image quality)** JPG fine JPG basic DNG + JPG fine DNG + JPG basic
Resolution These settings only affect the JPEG images. DNG can only be shot at the full 10 megapixels and when DNG only is set, this menu item is not available.	1 MP 2.5 MP 6 MP 10 MP
User Profile In conjunction with settings made in the Main Menu, it is possible to set up three frequently used setting combinations so that any one can be quickly selected without having to adjust a number of individual parameters. It might be convenient, for example, to have a particular combination of ISO and Compression settings combined with Lens Detection On and Auto slow sync set as Lens dependent.	Open profile 0 (restores factory settings) Open profile 1 Open profile 2 Open profile 3

The Main Menu

The MENU button to the top right of the viewing screen accesses the MAIN MENU. Although the range of functions is greater than the primary parameters accessed from the SET button, they have still been kept to a minimum to avoid extensive scrolling of the menu and sub-menus covering non-essential features.

Scrolling to each MENU item and then pressing the SET button accesses the sub-menus. Further scrolling selects the item in the sub-menu and pressing the SET button then sets this item. At this point, you can either scroll to the next menu item you require or close the Main Menu by pressing the MENU button or touching the shutter release.

Menu Items

Lens Detection: The sub-menu items are [On], [On + UV/IR], [Off]. If you are not using 6-bit coded lenses [Off] should be selected. [On] should be selected when using 6-bit coded lenses without a UV/IR filter and [On + UV/IR] when the lens is fitted with this filter. It is important to distinguish between the two [On] settings, as the firmware (from 1.102 onwards) corrects for a cyan drift towards the edges of the image caused by the filter when lenses of 35mm focal length or less are fitted to the camera. It should be noted that the transmission characteristics of IR-blocking filters other than the official Leica one (e.g., B+W IR486) are slightly different and some further correction in post processing may be necessary.

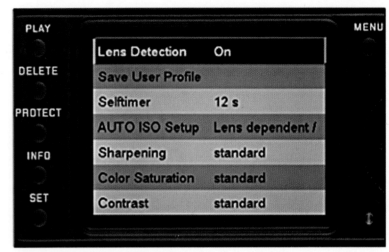

Showing part of the MAIN menu.

If the 16-18-21mm Tri-Elmar ASPH is attached to the camera, you will also be asked to set the appropriate focal length that is being be used with the lens. If this is not done, the default setting of 18mm will operate.

Save User Profile: Any combination currently set on the camera can be saved within the sub-menu with [Save as 1], [Save as 2], or [Save as 3]. As mentioned above, it is convenient to have your most frequently used combinations of picture parameter and menu settings quickly available by using the item in the SET menu.

Self-Timer: This can be set to 2 seconds or 12 seconds. Unless you have any particular reason to need a very short delay, I suggest leaving this set at 12 seconds.

AUTO ISO Setup (M8.2 and M8 from Firmware 2.00): There are two submenus: [Slowest speed] and [Max ISO]. [Slowest speed] has its own sub-menu with settings from [1/8] to [1/125] second, as well as [Lens dependent]. With these, you can set the minimum speed that is acceptable to you before the ISO sensitivity is automatically increased to compensate for the light levels and the lens aperture. The [Lens dependent] setting automatically adjusts the minimum speed according to the focal length of the lens in use, provided that the lens is 6-bit coded and lens detection is not set to [Off].

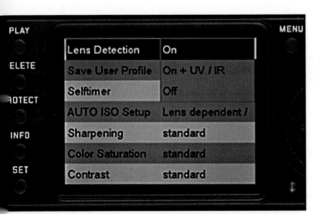

The sub menu for the Lens Detection options.

[Max ISO] allows you to specify the maximum ISO that you wish the Auto ISO function to set. If the light level and stop setting are such that the minimum speed and maximum ISO that you have set are inadequate, a slower speed will be set but this will flash as a warning. You can simply work with the slower speed or, if it is possible, either use a wider aperture or reset to a higher ISO.

I find the Auto ISO function very useful when working with available light or for close-ups as it saves having to reset ISO settings to compensate for reduced light levels or the need to stop down for depth of field reasons. My standard settings when using the function are 1/125 second and ISO 640. ISO 640 still provides decent quality files and most times 1/125 second is enough to minimize camera shake. If the shutter speed drops below this, I do get a warning and can act accordingly.

Sharpening, Color Saturation, and Contrast:
Each of these has five settings for different levels of adjustment of the image. Note that these settings are only effective with JPEG files; DNG images are not affected. There is an additional setting within [Color Saturation] for [Black and White] should you wish to shoot monochrome JPEGs. While this is a convenient way of achieving a monochrome picture without any post processing, most serious photographers requiring a monochrome image prefer to achieve their results by later adjustments of an RGB file in their computer.

My practice is to have all of these parameters set at [Standard]. This works well and it is very rarely that I find much need to adjust the JPEG images. For serious work, it is usually the DNG files that are being used and these have to be post processed anyway.

Monitor Brightness:
There are five settings ranging from [Low] to [High]. It may occasionally be useful to adjust this in exceptionally bright outdoor or dark indoor situations but, again, I have found the [Standard] setting to be adequate to cover almost all situations.

Histogram:
There are four settings: [Standard w/o clipping], [Standard with clipping], [RGB w/o clipping], [RGB with clipping].

At its size on the camera monitor the histogram, while being a good indication and helpful to an extent, is too small for very precise work. It is also based on the JPEG image, which retains less information in the critical highlight and shadow areas than the RAW (DNG) file. However, in the field, it can be very useful as a quick guide for a difficult exposure. I use [RGB with clipping].

Picture Numbering:
The two settings are [Continuous] and [Standard].

Auto Review:
Immediately after the picture is taken, the monitor can be set to show the image with or without the histogram and for a set period of time. The settings for duration are: [Off], [1 Second], [3 Seconds], [5 Seconds], and [Hold].

I find that the [3 seconds] setting is enough to see that a satisfactory picture has been taken. [Hold] retains the image on screen and is occasionally useful for more detailed assessments immediately, instead of having to wait for it to download from the buffer file and be available through the PLAY function.

Auto Power Off:
Pressing SET gives you options for automatically switching off the camera to save battery power. These are [2 minutes], [5 minutes], [10 minutes] or you can set [Off] so that the camera remains switched on until you turn off the main switch. This is not recommended as a normal setting—dead batteries are not fun! I feel that [5 minutes] works quite well, particularly since a light touch on the shutter release reactivates the M8 very quickly.

Flash Sync:
The options are the cutomary [1st Curtain] and [2nd Curtain]. The advantage of [2nd curtain] is that with a slow shutter speed the flash fires at the end of the exposure so that any ambient light blur is behind a moving subject prior to it being frozen by the flash. This gives a more natural effect.

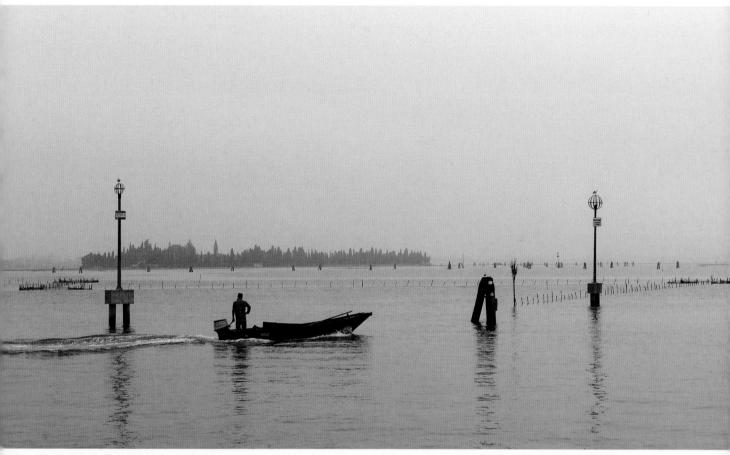

enice Lagoon near Burano. It is possible to shoot black and white images using a setting within the [Color Saturation] ub-menu. 50mm f/1.4 Summilux ASPH.

uto Slow Sync: This is the setting required if flash lus an ambient light exposure is required. As well as)ff (1/250s)], which will automatically set the fastest ash synchronization speed of 1/250 second when the utter is set to Auto, there are four other settings: .ens dependent], [down to 1/30], [down to 1/8], and own to 32sec]. When [Lens detection] is on with a -bit coded lens and the shutter is set to Auto, the .ens dependent] function will allow only a minimum mbient light shutter speed based on the inverse of the ns' focal length in millimeters. [down to 1/30] and

[down to 1/8] set the minimum shutter speed that will be set in Auto at 1/30 and 1/8 second, respectively. The full range of Auto shutter speeds is available with [down to 32 sec]. See the Chapter 7 for more information about these settings.

Color Management: The three possible settings are [sRGB], [Adobe RGB], [ECI RGB]. The normal setting is [sRGB]. The [Adobe RGB] and [ECI RGB] settings are only recommended for professional image processing in completely color-calibrated working environments.

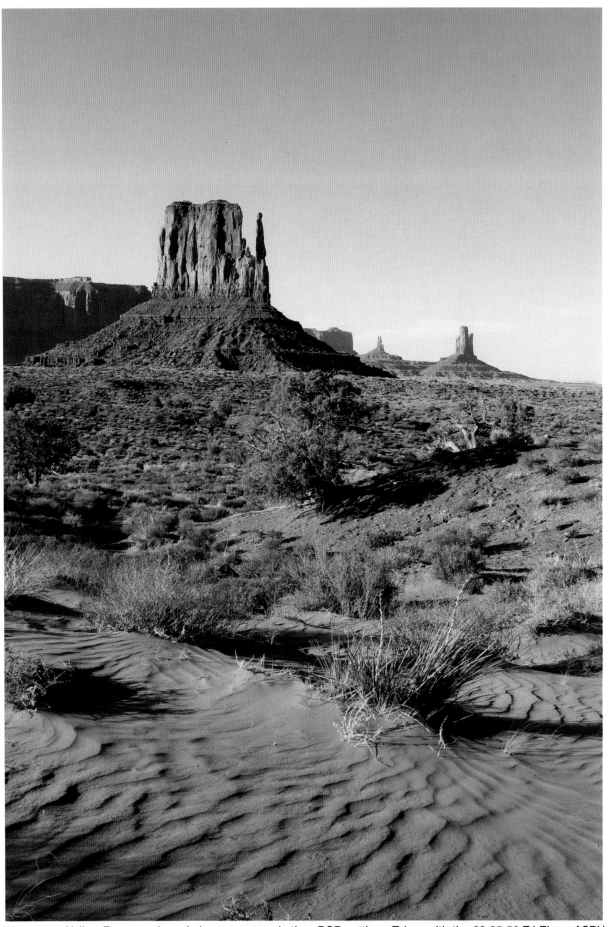

Monument Valley. For normal use Leica recommends the sRGB setting. Taken with the 28-35-50 Tri-Elmar ASPH. This is very useful in dusty environments as it often avoids having to change lenses.

eset: This provides the option to reset all the picture arameters to the factory defaults, clearing all current ttings and user profiles.

ensor Cleaning: Pressing SET gives you the ption to inspect the sensor. If, in response to [Inspect nsor?] you choose [Yes] and remove the lens, pressing e shutter release opens the shutter and the sensor can e inspected and cleaned. To close the shutter, switch e camera off. It is recommended that sensor cleaning e carried out only with a freshly charged battery.

ate and Time: These are set using the control dial a four-way controller.

coustic Signal: There are settings for [Volume], eyclick], and a warning for [SD Card Full].

anguage: There is a choice of several languages: nglish], [German], [French], [Italian], [Spanish], apanese], and [Chinese].

ormat SD Card: From time to time it is recom- ended to reformat an SD card in order to remove desirable artifacts and residual data from the card. It not normally necessary to format a card before use.

warned that formatting a card will remove all data, en protected files, so this operation should be carried t with forethought! When you press the set button to erate this setting there is a Yes/No reminder.

rmware: This tells you which version is currently aded onto the camera. Firmware is the reprogramma- e element of the software that controls the camera's gital processing. Early production cameras were sup- ed with version 1.06 or 1.09. This was updated with rsion 1.092 in March 2007 and version 1.102 in April 07. There were important changes particularly with spect to lens detection and processing when using /IR filters in 1.102. Version 1.092 was an intermedi- e release quickly superseded by 1.102 and later by

1.201. At the time of writing, the latest version is 2.00, which introduces the very useful Auto ISO function.

New firmware is easily downloadable from the Leica Camera website. It is in the form of a zip file and it is important to remember to unzip the file before attempt- ing to transfer it to an SD card and load it into the camera. The Leica instructions are in Appendix B.

Advance (M8.2 only): There are two settings: [Discreet] and [Standard]. When set to [Discreet] this feature enables quiet operation of the camera. By hold- ing the shutter release button down past the second pressure point, you delay the automatic motorized shut- ter-wind that is responsible for most of the noise, so that the sound of the shutter closing can be muffled under a coat or prevented until a suitable opportuni- ty occurs. Be aware, however, that when [Discreet] is enabled, you cannot take more pictures until the shutter is closed.

The S (Snapshot) Mode of the M8.2

The S mode is a useful function for Leica M digital owners who desire the superior quality of the iconic Leica M with the simplest possible operation. To this end, the options available with the Picture Parameters and the Main Menus have been reduced to a minimum.

Within the Picture Parameters settings, the SET button is inoperative. The camera is automatically set to [AUTO ISO], [JPG fine] at [10 MP] resolution and [Auto White Balance]. If you press the INFO button when S mode is set on the shutter dial and no image has been selected with PLAY, the viewing screen will show focusing and f/stop recommendations (with a depth-of-field indication for the lens fitted) for the three most common picture requirements. These are [Landscape], [Individual Portrait], and [Group Portrait] and are shown individually by cycling through the options with the INFO button. Note, however, that these are only available if you are using a Leica 6-bit coded lens of 35mm or wider focal length. When a picture being reviewed in PLAY, pressing the INFO button is ineffective; there is no histogram and no other information provided.

In the Main Menu, only five settings are offered. These are [Image Settings], [Date], [Time], [Language], and [Format SD-Card]. The options under [Image Settings] are [Color] or [Black + White].

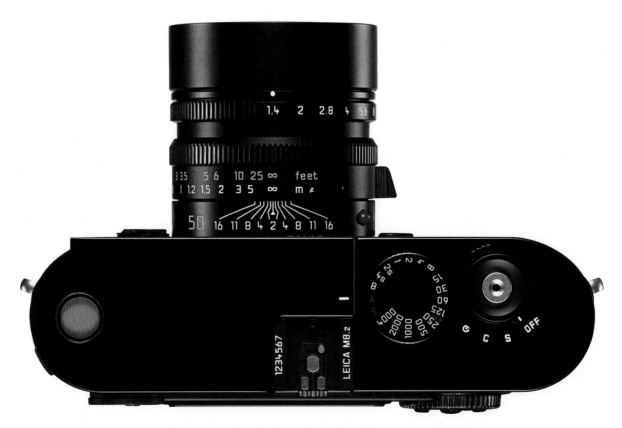

The top plate of a black M8.2 showing the revised shutter speed dial with S mode and no 1/8000 second speed setting.

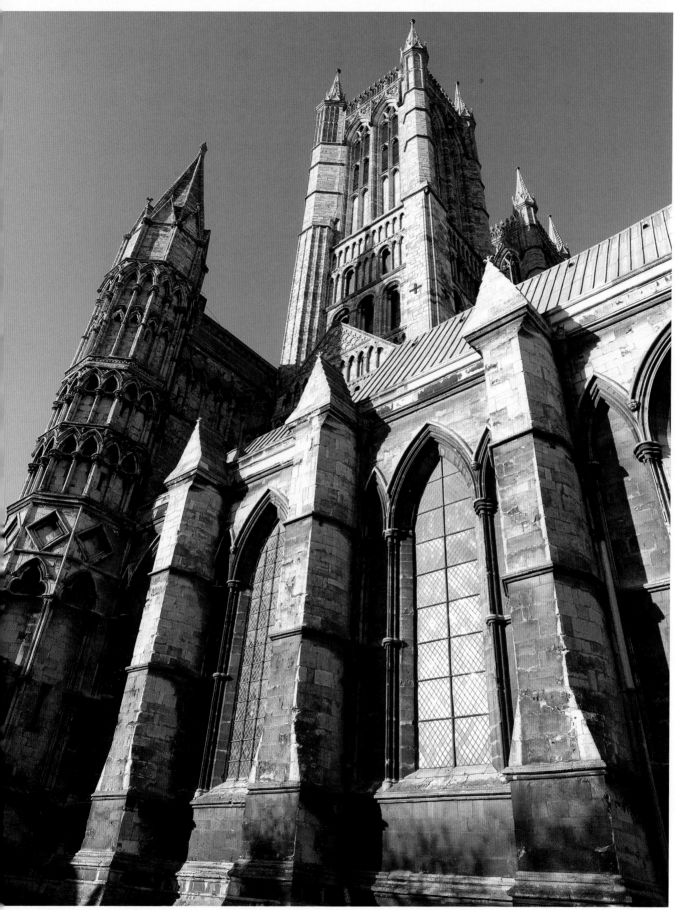

incoln Cathedral. An example of the qualities of the 16-18-21mm Tri Elmar ASPH at 16mm.

Leica M8 Lenses

Background

L eica lenses have always had an enviable reputation for their performance and quality of build. Many of the current range are class benchmarks and Leica has gone to considerable lengths to ensure that the outstanding capabilities of its lenses can be fully achieved by the M8 sensor/firmware combination. This has meant that some compromise has been necessary with the designers eschewing moiré (anti-aliasing) and heavy infrared filtering in order to realize their objective. Their approach has enabled the M8 to retain not only exceptional sharpness but also the unique quality and character of Leica lenses that is so loved by aficionados.

Leica's reputation for producing superior photographic lenses was established from the earliest designs. Over the years, many Leica lenses have been optical landmarks. The original 50mm Elmar that Max Berek designed for Oskar Barnack's earliest Leicas is an acknowledged classic. It was instrumental in establishing the viability of 35mm photography. By incorporating new types of glass, the first Summicron of 1953 established remarkable new levels of performance for standard focal length lenses. In 1968, the 50mm f/1.2 Noctilux became the first production lens to use aspher-

The first Summicron was the 1953 50mm design. It represented a breakthrough in optical design using new glass formulations developed in Leica's own laboratory. © Brian Bower

ic elements and the subsequent 50mm f/1 of 1976 was the fastest ever lens in regular production. More recently the range of ASPH lenses for the Leica M has successfully exploited new design and production technologies. Many of these early achievements were the result of Leica having had the foresight in the 1950s to establish its own research laboratory to investigate and develop new types of optical glass. For the more sophisticated lenses, glasses of anomalous partial dispersion and high refractive index are essential, and Leica led the way in developing these designs.

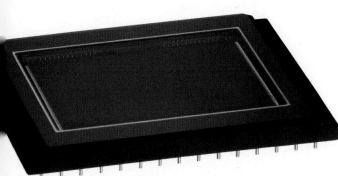

The M8/8.2 sensor was developed in close cooperation with Kodak. It is designed to cope with the short distance from the image plane to rear lens elements that is a feature of many Leica lenses, especially wide angles. Other features are designed to preserve the image quality that is characteristic of the Leica lenses.

Image Quality

Leica lenses have consistently retained a special quality, characterized not just by the sharpness and correctness of the images they produce but also by remarkable luminosity and the ability to differentiate subtle hues and tonal values. The lenses also have what the Japanese call good bokeh. This term describes a harmonious relationship between the sharply focused subject and the out-of-focus areas of the image—in particular, the way out of focus backgrounds and foregrounds are rendered. The optical configuration of the lens, the position and shape of the diaphragm, and the way the designer has chosen to correct particular aberrations all contribute to the shapes and the softness or harshness of these out-of-focus areas. An extreme example of the absence of bokeh is the characteristic way in which mirror lenses render out-of-focus highlights as doughnuts. Bokeh is certainly one of those qualities that add up to that difficult-to-define Leica quality. As with other subtle factors, it is something not revealed by lens test charts or MTF (modulation transfer function) curves, but is readily obvious to experienced photographers or anyone who is conscious of overall image quality.

The fact is that while computer evaluation and scientific testing of many aspects of performance are essential when developing a lens design, they cannot analyze all the subtleties and the complex aspects involved in reducing a three dimensional subject to a two dimensional image. This is true of even the most sophisticated design and test facilities with the most highly qualified optical experts available to interpret and analyze results. Only years of experience and know-how will ensure that the various optical compromises involved will produce a lens whose performance will delight photographers even more than it does lens testers.

Of course, the best way to test a lens for photographic image quality is to go out, take pictures with it in a variety of situations, and compare the results with an equivalent lens of known high quality. It is important to use the lens according to the purpose for which it was designed; and for the comparisons to be valid they must be of the same subject, at the same time, with the same lighting, and the sensor should be of equal quality.

Design Considerations

Lenses are optimized for different requirements. A wide aperture f/2 or f/1.4 lens will have quite different design aims from a macro lens of equivalent focal length. The essential requirements of the macro lens will be to ensure that good corrections are maintained within the extreme close focusing range, as well as for more distant subjects. It will also need to have a flat field of sharp focus with absolutely minimal distortion, as it is likely to be used for copying work or photographing other close-up detail on a flat plane. In order to achieve all of this, it is unlikely that the maximum aperture will exceed f/2.8. It is worth noting that for the more extreme close-ups (larger than life size), Leica has designed the special Photar lenses, which are designated for specific ranges of magnification. These can be used with the M8, the (discontinued) Visoflex system, and/or its associated bellows unit (see Chapter 8).

Conversely, a high-speed lens such as a Noctilux will not be able to perform at its best in the near range—below about six feet (2m)—especially at its wider apertures. Flatness of field is not quite so critical and some minimal distortion will be of less consequence for the kind of available light subjects where such lenses are most likely to be used. Good contrast and definition, especially in the center of the image at full aperture, and freedom from flare and reflections, together with good correction for optical aberrations will have the higher priority. The latest Summilux 50mm has a floating element which moves to significantly improve performance in the near range, but even so, a simpler design like the Summicron still has the edge when it comes to focusing at very close distances.

ide-angle lenses present a different problem. With the eater angle of view, the problems of controlling dis- rtion and minimizing vignetting increase significant- , and with wider apertures so do other optical aberra- ons. With the M series cameras, there is also the added sign complication of keeping the dimensions as com- ct as possible. It is particularly important to minimize

any obstruction of the viewfinder by a large front lens element because you must be able to see through the viewfinder in order to compose and focus.

ower Rotorua. It is very difficult to maintain the corrections of fast lenses in the close up zone (less than six feet or two eters). Leica have now started introducing floating elements that move to help maintain the corrections in this zone. The mm f/1.4Summilux M ASPH used for this flower shot is one example.

Aspheric Elements

For some time optical engineers have incorporated aspheric lens elements into wide-aperture and wide-angle lenses to achieve better corrections and vastly improve performance. Aspheric glass can especially help at wide apertures to improve image quality at the edges of the format and reduce some amount of vignetting. The problem with aspheric elements has always been the very high cost of production. With the development and perfection of new manufacturing technologies, Leica has been able to reduce costs and incorporate aspheric elements at much more reasonable price levels than previously.

The advantages are particularly exemplified with the 35mm f/2 Summicron M ASPH. Although its non-aspheric predecessor is certainly highly regarded, the new lens clearly demonstrates superior edge quality at f/2 and f/2.8, and to a lesser extent at f/4. All lenses naturally vignette; it is an inescapable optical law that the illumination at the edges of the image will always be less than at the center. Put simply, this is because the light rays have farther to travel from the outer edges than from the center because they are not perfectly perpendicular to the film or sensor plane. The wider angle the lens, the greater proportionately is this light loss. The table below shows how critical this light fall-off becomes as the angular field is increased.

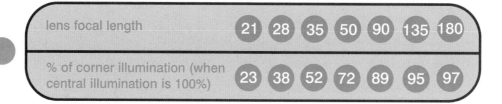

lens focal length	21	28	35	50	90	135	180
% of corner illumination (when central illumination is 100%)	23	38	52	72	89	95	97

Bowlers at Government Gardens Rotorua. The use of aspheric elements has enabled great strides to be made in the performance of many wide aperture and wide-angle Leica lenses. 28 mm f/2 Summicron M ASPH.

ot only can lens designers do very little to improve on these figures, but lenses so suffer from another type of vignetting, known as system vignetting, which mpounds the problem. This is the result of both the optical and mechanical nstruction of the lens, and becomes more pronounced as the maximum aper- re is increased. Leica goes to great lengths to minimize system vignetting, and is generally eliminated by about f/4 or f/5.6. The ASPH lenses also achieve uch reduced system vignetting at the wider apertures. With the help of this bril- ant optical technology, the designers have been able to reduce it at f/1.4, f/2, d f/2.8 on the latest wide-angle M lenses.

Apochromatic lenses

We are all familiar with the way a prism splits white light into the component colors of the spectrum from red at one end to violet at the other. The trick for the optical designer is to ensure that when his lens "bends" the light to form an image, the different colors are still brought back to the same point of focus; otherwise, the image will not be sharp. Correcting the various chromatic aberrations is extremely difficult and particularly so with longer focal lengths as the maximum aperture is increased.

Convention has been that if a lens is properly corrected for the two wavelengths at each end of the visible spectrum (i.e., red and violet), the remaining ones will also be adequately corrected. With short to medium focal lengths, there is more than sufficient depth of focus at the image plane for this to be true. This is the traditional achromatic correction. With longer focal lengths at wider apertures, even a very small degree of deviation is unacceptable, and to achieve the highest image quality with all colors and maximum sharpness, a further correction is necessary. The lens is then said to be apochromatic.

The improvement in quality with fast lenses of longer-than-normal focal length has been significant. However, the development and production costs of such lenses are very high indeed. They require sophisticated glass types and very precise assembly. The benefits can be clearly seen in the image quality, especially at wider apertures. The 75 and 90mm Apo-Summicron-M ASPH lenses have won universal acclaim for their performance.

Lens Coatings

Without anti-reflection coatings, it would be impossible to produce many of today's complex multi-element lenses. Reflection losses at every glass/air surface could easily halve the total light transmitted to the sensor and there would be massive loss of contrast due to flare.

Leica has been factory coating their lenses for over fift years, and during this period, has been at the forefront of many significant developments in this field. These have been crucial to improving not only lens performance but also other optical components in the camera such as viewfinder and rangefinder prisms.

For coatings to achieve maximum effectiveness, the correct material and the thickness and number of coatings for each individual lens surface to be treated must be very precisely calculated, and then applied just as precisely. The material is deposited on the untreated glass elements in a vacuum kiln in which the appropriate metal oxides and fluorides are vaporized. The average thickness of a coating is 1/10,000 millimeter!

Multiple coatings of different materials and thicknesses are applied, usually six at Leica, to achieve a broadband resistance to reflections. Even in the most complex lenses (which can contain up to twenty glass/air surfaces), a light transmission efficiency of over 96% can be achieved.

Leica now uses the latest ion-aided process for the deposition of the coating material. This has several advantages. Because much lower temperatures can be used in the kiln, there is relatively little stressing of the lens elements as they heat up and cool down again. The evenness and thickness of the coatings can be controlled even more precisely, and they are denser and harder with better adherence to the lens surface. In addition to improving performance, this adds to resistance against scratches and chemical contamination.

Mechanical

No matter how brilliant the optics of a lens may be, it counts for nothing if it is not assembled accurately in the first place, in a mount that is designed to maintain that accuracy, and robust enough to give trouble free service in all the arduous situations that a professional photographer is likely to meet.

Leica has never compromised on engineering quality and this applies just as much to their lenses as it does to their cameras. There are many Leica rangefinder lenses still in regular use that are over thirty years old. Some were even used for photos in this book!

Leica fully realizes that a lens is a photographer's working tool and it is it's job to ensure that it is built in such a way that the wonderful imaging performance of which it is capable is maintained for a busy photographer who has no time to baby his or her equipment.

Some examples of Leica's manufacturing standards are: an ability to work satisfactorily at temperatures from -4°F to 122°F (-20°C to 50°C), a bayonet mount that shows no discernible wear after many thousands of lens changes, shock resistance to 100g, and a focusing movement that remains smooth and free from stickiness and backlash for many, many years.

Compared with other manufacturer's products, Leica lenses are no lightweights. Much more metal is used in the mount construction—in particular, the focusing helicoid is usually a combination of aluminum alloy and brass, rather than aluminum with polycarbonate. This is not because of any aversion to modern synthetic materials, but simply a desire to use those that are most suitable for the required task. One example of this is that the optional silver chrome finish for some lenses in the M system requires that the outer mount be made from brass, rather than the aluminum alloy of the black finish lenses. This is a heavier construction but it does ensure that as high a quality chrome finish as possible can be achieved.

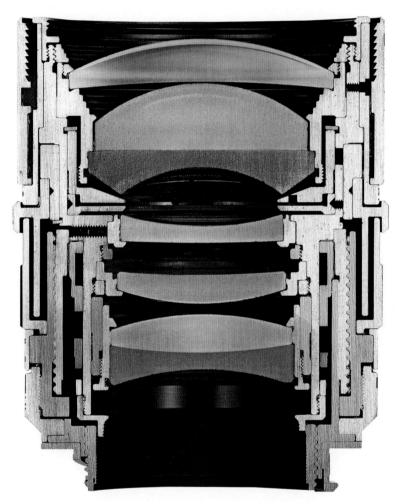

This cross section of a 50mm Summilux-M ASPH shows the complex mechanical construction needed to ensure smooth operation with a long, trouble-free life.

The Current Range of Lenses for the M8 System

It is generally accepted that the current Leica M lens line includes some true benchmarks for optical and engineering quality. The results can be clearly seen in the superior images that the M8 is capable of producing. It should always be remembered that even in this digital age the lens is the first, very critical link in the chain of image quality. Leica's aim has always been to continuously strive to ensure that it's lenses meet the very highest standards possible.

One of the great attributes of the M system is its compactness. Unlike an SLR camera, there is no need to have space for a mirror box. Particularly with wide-angle lenses, it has never been necessary to use a reverse-telephoto design to provide the required clearance for the mirror.

Unfortunately, this short distance (back focus) from the focus plane on the sensor to the rear element of some lenses was a major hurdle in the development of the M8. Individual pixels on a CCD sensor have light concentrated and directed towards them by micro lenses. These pixels are most effective when the light rays reach them in a straight line. As the angle of the rays

becomes more oblique towards the edges of the image, there is a significant loss of light. This adds to the vignetting inherent in any lenses, especially in wide-angle lenses, which is a notable problem even with SLR cameras, despite their lenses having the increased back focus to leave room for the mirror mechanism. Leica in collaboration with Kodak who supplies the M8 sensor, developed a special micro lens structure with the micro lenses at the edge of the sensor shifted laterally. Any filters or cover glass in front of the sensor can also cause unusual refraction of the oblique light rays and it is for this reason that these have been made as thin as possible or eliminated altogether.

At the time of writing, there are 20 Leica M lenses covering 10 focal lengths ranging from 16 to 135mm. With the M8, the focal length of each lens is effectively increased by a factor of 1.33 because the dimensions of the sensor are 18 x 27 mm, compared with the 24 x 36 mm format of the film cameras. The table below indicates the effective focal length of each lens when fitted to an M8 or M8.2.

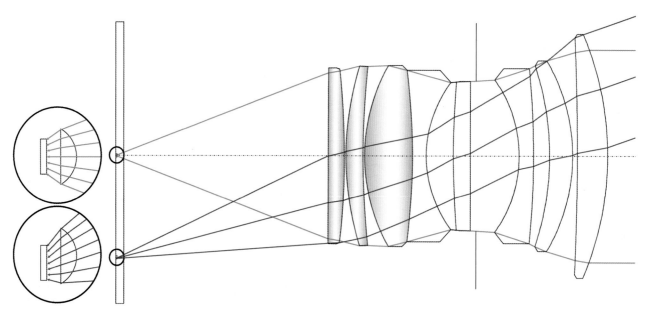

The unique sensor for the M8 series incorporates a specially designed micro-lens structure to achieve maximum performance from the Leica M lenses.

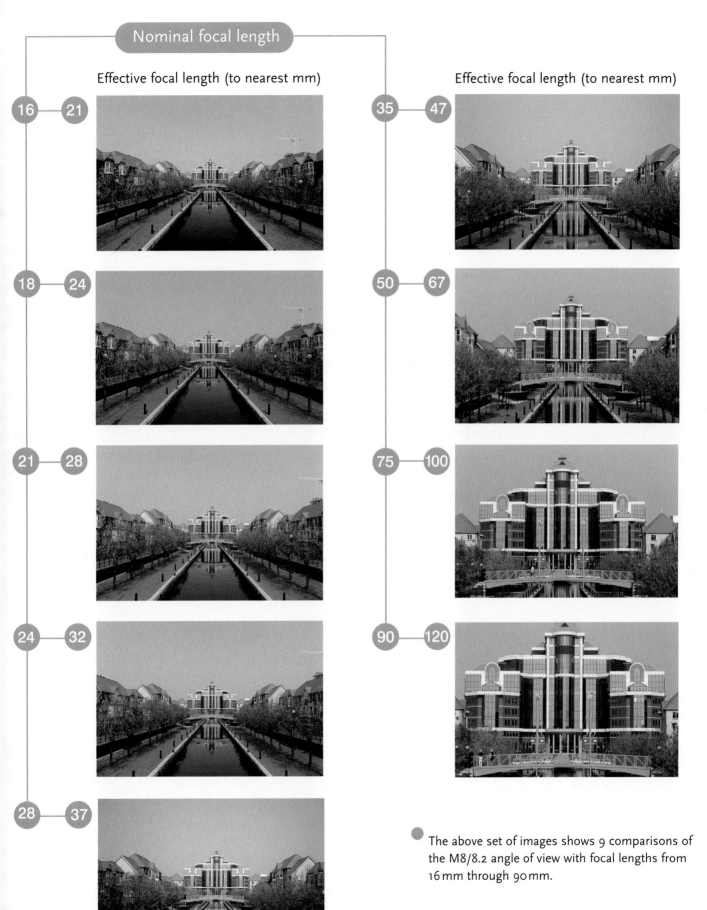

Nominal focal length

Effective focal length (to nearest mm)

Effective focal length (to nearest mm)

16 — 21

18 — 24

21 — 28

24 — 32

28 — 37

35 — 47

50 — 67

75 — 100

90 — 120

The above set of images shows 9 comparisons of the M8/8.2 angle of view with focal lengths from 16 mm through 90 mm.

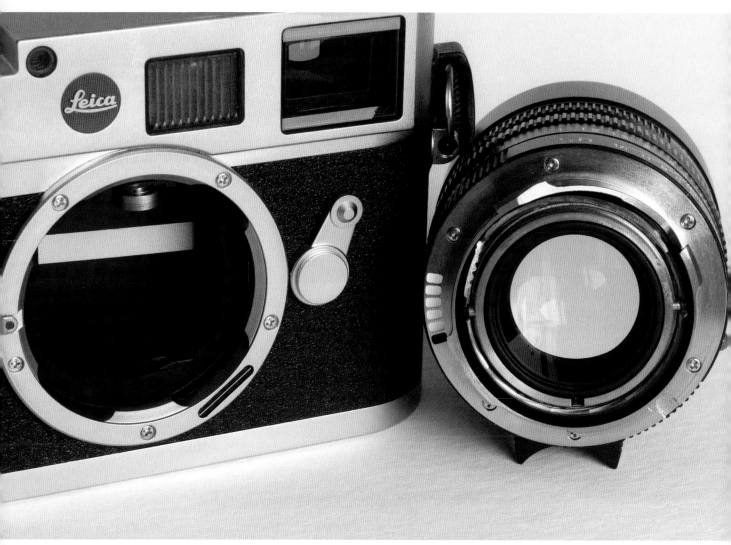

The data from the 6-bit code on the lens is read by a sensor on the camera's bayonet mount. © Brian Bower

If you wish to make a precise calculation, the exact focal length of any Leica M lens of 50mm or longer can be derived from a figure which is engraved on the focusing mount. For instance, on a 50mm Summicron you may find a figure 16 engraved near the infinity setting on the focusing scale. This indicates that the true focal length of this particular lens is 51.6mm, thus the effective focal length on the M8 would actually be 68.8mm.

In order to transmit information for EXIF data with M8 images, all recent Leica M lenses have a 6-bit coding on the lens mount. This feature not only records the focal length but also enables the camera firmware to compensate for any inherent vignetting as well as col variation in the corners of the image when a UV/IR filter is fitted to a wide-angle lens. With suitable flash units it will also automatically adjust the angle of the beam appropriately. Note that when using non-coded lenses, the menu item for the [Lens detection] functior should be set to [Off] in order to avoid false information being signaled to the firmware.

With very, very few exceptions (see chapter 4) all Leic M lenses can be fitted to the M8. Early 21 and 28mm lenses will not meter correctly because their deeply recessed mounts obscure the metering cell. Also, the peripheral rays reach the sensor at a more extreme

ngle so that there is likely to be increased vignetting. xposure, however, can be set manually either by using separate meter or checking first with another suitable ns on the camera.

here is no frame appropriate to the 135mm focal ngth. The lens focal length would effectively be 80mm, and not only would the brightline frame be too nall for practical use, but the accuracy of the ingefinder would probably be insufficient. A 180mm ns on an M8 could sometimes be useful, but besides king a chance on guessing at framing and focusing ccuracy, there is a solution. The discontinued 135mm 2.8 Elmarit M was fitted with "goggles" that magni- ed the viewfinder image by 1.5x. Thus, the 90mm ame became appropriate for 135mm. In the case of ie M8, this would be 180mm. It is still necessary to se care when focusing, but even by modern stan- irds it is still a very competent performer, and there e still some decent ones out there on the used mar- t (see Chapter 4).

ie comments below on individual lenses are based pri- arily on direct experience rather than lens testing arts. A full technical analysis of each lens is available Leica's website (www.leica-camera.com), which pro- des graphs of MTF curves as well as the vignetting id distortion figures. All the graphs cover the applica- on of the lenses with the full 35mm (24 x 36 mm) for- at. When considering them in relation to the M8 for- at, the readings at the 15 mm point on the Y-axes are e relevant ones. Leica, however, is always quick to oint out that numerical analyses of lens performance, though very valuable indeed, do not reflect the many ibtleties that make up the extremely important overall iaracter of a lens. Nor can they show the practical fect of imaging a 3-dimensional subject, as opposed a test based on a flat plane at the optimum point of cus. The publicized charts usually only show the per- rmance at infinity (actually 100x the focal length), hereas in practice, lens performance can vary over the cusing range. High-speed lenses in particular can metimes show a noticeable deterioration in the close nge—below about six feet (two meters). There is also

the much-debated issue of bokeh that has to do with the rendition of the out-of-focus areas of the image. Leica lenses are often acknowledged to have a special character that is impossible to show with a chart.

The Leica M is the ultimate available light camera, the darling of many photojournalists. This has always demanded fast (wide aperture) lenses to take advantage of the abilities of the rangefinder system in poor light. With the M8, the ability to set ISO speeds right up to 2500 has enhanced the system's abilities even further, and for photography in normal light it has made the restrictions inherent in lenses of more modest maxi- mum aperture less critical. Thus, the restrictions imposed by the use of the slower f/4 and sometimes f/2.8 lenses are less significant with the M8/M8.2, so that convenience, compactness, and cost can sometimes be allowed a bigger say when choosing an outfit.

Wide-Angle Lenses

Wide-angle lenses play an especially important role in the M system. Not only do they have many creative advantages, but also this camera encourages a direct style that involves working with and close to a subject, rather than standing back with a long telephoto. This explains its long-standing position as a favorite of pho- tojournalists and street photographers. Leica has risen to the challenge by providing a range of fast, high- quality wide-angles.

Tri-Elmar–M 16-18-21mm f/4 ASPH (M8 series effective focal length – 21-24-28mm): Prior to the introduction of this lens at Photokina 2006, the widest M lens was 21mm. For the M8, this is an effective 28mm. As well as providing an extreme wide angle for the film cameras, this Tri-Elmar provides an important 21mm focal length equivalent for the M8. This has been a favorite of many photographers (author included!) and it is great to have this angle of view available for the digital option.

At all three focal lengths, this Tri-Elmar performs exceptionally well, even at maximum aperture. The performance when set at 21mm is in fact virtually equal to that of the 21mm f/2.8 ELMARIT-M ASPH set one stop faster (i.e., performance at f/8 is equal to the ELMARIT-M ASPH at f/5.6). Image quality is excellent throughout the range but f/8 is probably the optimum stop. Its performance at 16mm is remarkable with amazingly little vignetting and minimal distortion for a lens of this focal length.

The relatively modest maximum aperture of f/4 is rarely a problem with super-wide lenses. They can be hand held at relatively slow shutter speeds and the option to turn up the ISO setting on the M8 for a particular requirement if the need exists further helps to prevent blur caused by camera movement (see Appendix C about setting this lens for UV/IR filters and correct EXIF data). The lens has seven lens groups with ten elements, two of which have aspherical surfaces.

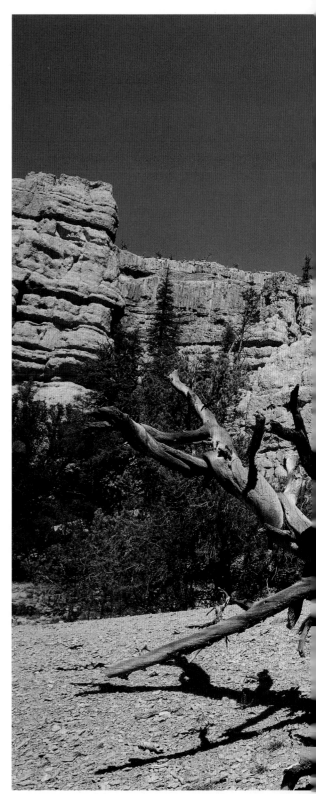

Red Canyon, Utah. 16-18-21mm f/4 Tri-Elmar-M ASPH a

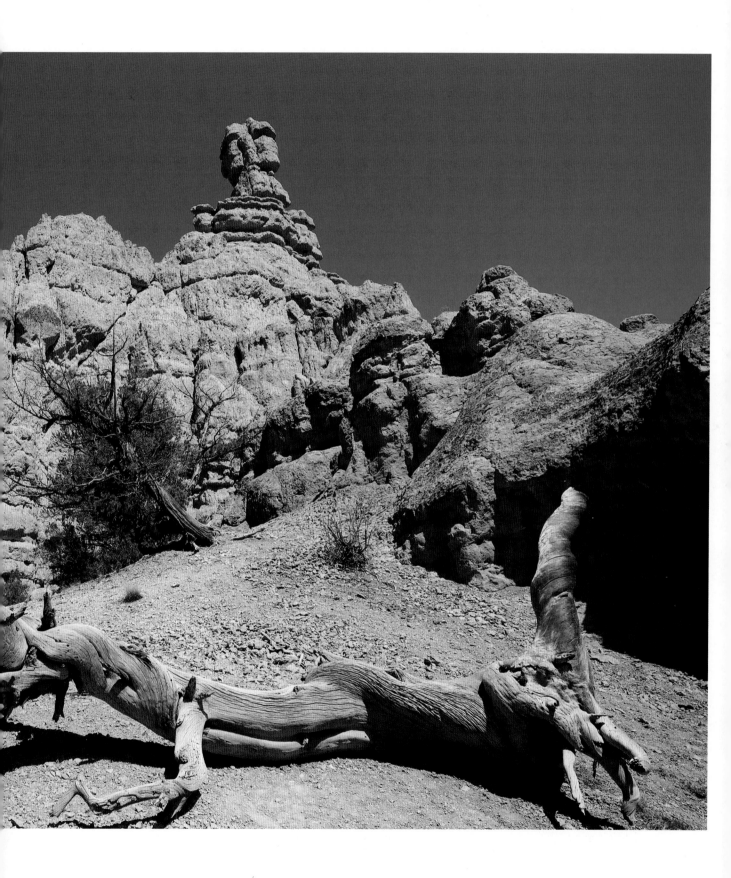

The Reebok Tower Bolton. The 16-18-21mm f/4 Tri-Elmar-M ASPH at 18mm

me Hall, Cheshire, England. The 16-18-21mm f/4 Tri-Elmar-M at 21mm

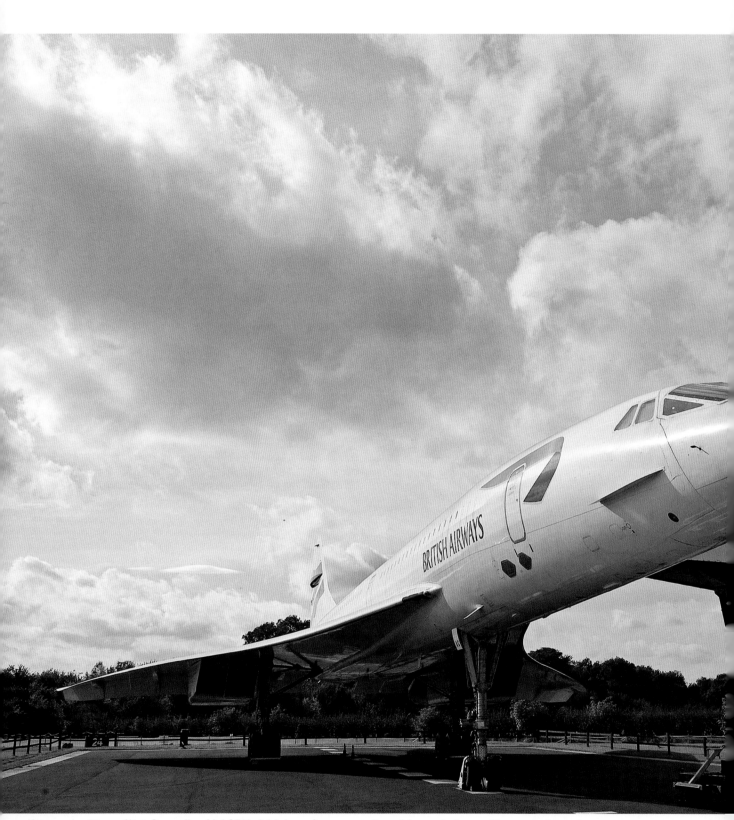

Concorde. 21mm f/1.4 Summilux-M ASPH. A high performance ultra wide-angle lens with an aperture of f/1.4 is a remarkable achievement.

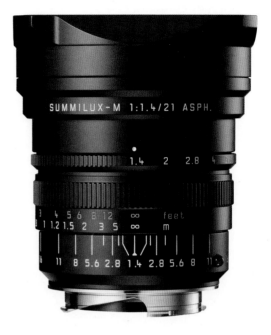

Summilux-M 21mm f/1.4 ASPH (M8 series effective focal length - 28mm): This was one of four new lenses announced by Leica at Photokina 2008. An f/1.4 lens of this focal length capable of covering the full frame 24x36mm format is an amazing achievement. M8 series users have an effective 28mm f/1.4 lens, highly advantageous for photojournalistic work and also to allow an opportunity for wide aperture selective focus effects. In order to attain its outstanding performance two aspheric elements as well as advanced glass types have been incorporated in the design. Vignetting and distortion have been controlled to such remarkably low levels that they are hardly noticeable in all but the most critical applications. The overall performance is excellent. This includes the close-focus range thanks to the use of a floating element. The lens is bulkier and almost twice as heavy as the 21mm Elmarit-M ASPH. The supplied rectangular lens hood accommodates a series VIII filter; alternatively an adapter that takes 82mm filters is available as an accessory. There are ten elements in eight groups with two aspherical surfaces.

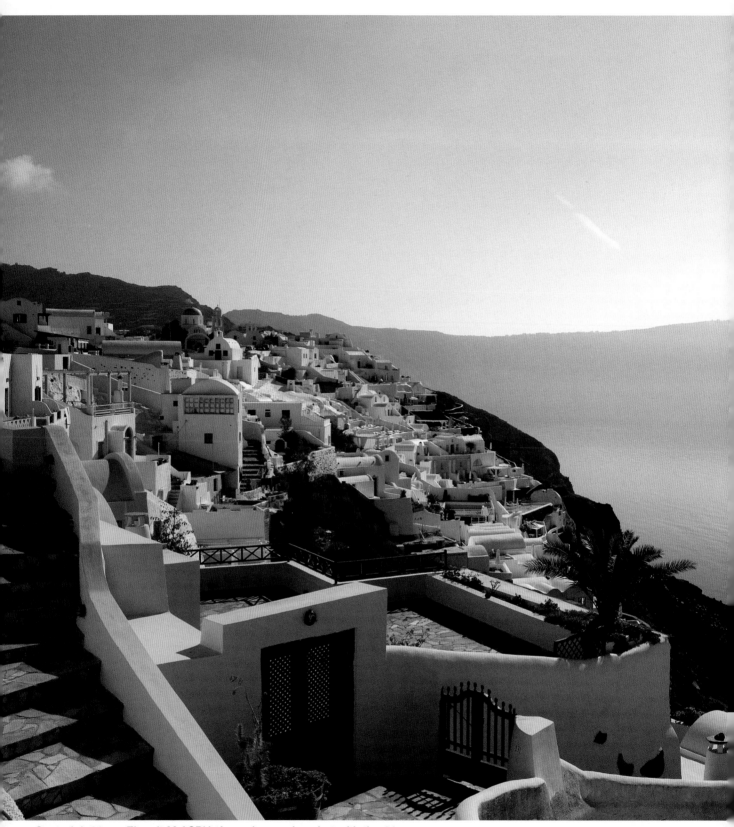

Santorini. 21mm Elmarit-M ASPH. An early morning shot with the 21mm.

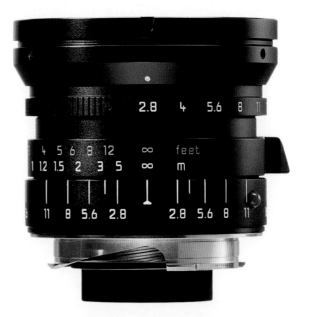

Elmarit-M 21mm f/2.8 ASPH (M8 series effective focal length - 28mm): This is the fourth 21mm that has been developed for the M system and it is a superb performer. Optimum aperture is f/5.6 or f/8 for the very best definition of important detail at the edges of the frame but the lens can be used confidently even at its maximum f/2.8. The lens is free from flare but the strings of diaphragm reflections that plague very wide-angle lenses can occasionally occur when the sun is positioned at certain angles within the image area. There are nine elements in seven groups with one aspherical surface.

Elmarit–M 24mm f/2.8 ASPH (M8 series effective focal length – 32mm): This lens is often considered to be one of the very best lenses available in this focal length. An effective 32mm, the angle of view with the M8 is slightly wider than the classic 35mm focal length used on the film cameras. Distortion is 2%, slightly higher than some other Leica wide angles, but even at this level, it would still be virtually undetectable except with a very precise subject—for example, architecture—with straight lines close to the edges of the image area. There are seven elements in five groups with one aspherical surface.

The Pride of Rotterdam. 24mm f/2.8 Elmarit-M ASPH .

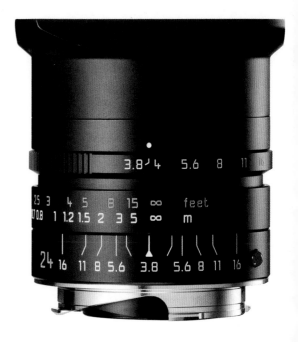

Summilux-M 24mm f/1.4 ASPH (M8 series effective focal length - 32mm): This is another member of the Photokina 2008 quartet of M lenses and an equally amazing achievement to its 21mm sibling. In this case only one aspheric element was used to reach the same outstanding level of performance. Again a floating element has been incorporated to maintain quality in the close focus range. For M8 series cameras the effective 32mm focal length provides a near equivalent to the popular 35mm Summilux ASPH on full-frame format M cameras. As might be expected this lens is quite bulky and heavy when compared with the 24mm Elmarit-M or 3.8 Elmar-M ASPH lenses. With full frame format cameras a separate viewfinder is required. With M8 series models the built-in brightline frame is obscured to a significant extent when the lens hood is fitted and it might be an advantage sometimes to use an accessory finder. The lens hood takes series VII filters and there is an accessory filter holder available for E72 filters. There are ten elements in eight groups with one aspherical surface.

Elmar-M 24mm f/3.8 ASPH (M8 series effective focal length 32mm): Leica has made a particular effort to include a compact and more economically priced lens in each of the most popular M focal lengths while at the same time providing extremely high levels of performance. For the 24mm range this has been achieved with the Elmar. At full aperture the performance is outstanding, stopping down is really only needed to increase depth of field. The performance is also well maintained in the close focus zone. A distortion level of only 1% is especially low for a lens with this angle of view and would hardly be noticeable even in critical applications. There are eight elements in six groups and one aspherical surface.

Cottages, Great Budworth, England. 24mm f/3.8 Elmar-M ASPH. This new 24mm is a particularly compact lens of exceptional performance.

Sydney Opera House. 28mm f/2 Summicron-M ASPH. It was a surprise to discover that the roof structure was covered with thousands of tiles. This lens is one of the author's favorites.

Summicron-M 28mm f/2 ASPH (M8 series effective focal length - 37mm): On the M8, this is the equivalent of the classic 35mm Summicron that regular M film camera users consider to be "the lens" for the system. It is an outstanding lens that provides top quality performance even at the f/2 maximum aperture. There is some slight improvement in the corners of the frame on stopping down. Although it is quite compact when compared with earlier 28mm lenses, there is some intrusion into the viewfinder brightline frames, especially at closer distances and with the lens hood fitted. A favorite of many M8 photographers, the lens features eight elements in five groups with one aspherical surface.

marit-M 28mm f/2.8 ASPH (M8 series effec-
ve focal length – 37mm): The new Elmarit 28mm
as introduced at the same time as the M8 camera. It is
remarkably compact lens whose performance almost
atches the much more expensive 28mm Summicron
SPH at similar stops. Distortion is, for all practical
urposes, nonexistent. As discussed previously, in many
tuations absolute lens speed is less critical with the M8
an with a film camera, as the ISO setting can be quickly
anged for individual shots. This is the most compact
ns for the M system and is a very effective and eco-
omical alternative to the Summicron. There are nine ele-
ents in five groups with one aspherical surface.

e Dom, Boppard, Germany.
though a stop slower than the clas-
c Summicron, the 28mm f/2.8
marit-M ASPH is an excellent per-
rmer and very compact.

Summilux-M 35mm f/1.4 ASPH (M8 series
effective focal length – 47mm): This lens is crafted
in the tradition of the limited-edition 35mm Summilux
Aspherical, which had two aspheric elements produced
by traditional lens grinding methods, and was the first
ASPH type. A new production process using blank
pressing and special ceramic tools was developed and
this substantially reduced the manufacturing cost of an
aspherical surface. Although the lens now only has one
aspherical surface, the level of performance is virtually
identical to the special limited edition lens. In both cases,
a significant increase in performance over the earlier
non-aspherical lens was achieved. There are nine ele-
ments in five groups with one aspherical surface.

Summicron-M 35mm f/2 ASPH (M8 series effective focal length – 47mm): This has long been the classic M lens for the full-frame format. The current design is the fifth in the series. It has fully exploited the opportunities provided by new design concepts and aspheric technology. It costs less and is much more compact than the Summilux. At the widest apertures, f/2 and f/2.8, the Summilux is a marginally better performer in terms of detail resolution, but there is no discernible difference at the smaller stops. Distortion and vignetting are slightly less with the Summicron. There are six elements in six groups with one aspherical surface.

e Kingston Flyer, South Island, New Zealand. 35mm f/2 Summicron–M ASPH. On the M8/8.2 a 35mm lens provides the uivalent of the standard 50mm on a full frame camera.

Summarit-M 35mm f/2.5 (M8 series effective focal length – 47mm): The Summarit group of lenses was designed to exploit the latest techniques to achieve the maximum possible quality at reasonable cost. By restricting the maximum aperture to f/2.5, it was possible to avoid the expensive production processes required for the wider aperture ASPH and APO lenses. The 35mm Summarit is an excellent performer. It is also very light and compact and makes a nice package with the M8. By f/5.6 or f/8 it would be difficult to distinguish the results with this lens from those with the Summilux and Summicron lenses of equivalent focal length. The nearest focusing distance is slightly reduced from 27.56 inches (70 cm) to 31.5 inches (80 cm). There are six elements in four groups and there are no aspherical surfaces.

Building detail, Hamelin, Germany. 35mm f/2.5 Summarit-M. This lens is extremely compact and economically priced.

Medium Focal Length Lenses

Many M8 users have found that the slightly narrower field of view that this camera achieves with the 50mm lenses is very acceptable for many subjects. Leica has consistently produced outstanding designs at this focal length and the current range is no exception.

2008. At Photokina of that year a new f/0.95 version was announced. Befitting a flagship model this new design takes advantage of all the latest optical and manufacturing technology to "break the optical sound barrier of lens speed 1:1" as Leica put it in their press release.

The lens has two aspherical elements that, due to their size, demand a particularly complex manufacturing process. Three of the eight elements are also made from exceptionally expensive glass (double the cost of silver according to Leica). There is a floating element for improved performance in the close focus range. Despite all this, the size and weight have been kept very close to the predecessor lens. For all the above reasons manufacturing costs are high and with limited production the price is inevitably, to say the least, elevated!

At full aperture this lens retains the characteristic bokeh that, together with the extremely shallow depth of field was a notable feature of the previous version. When stopped down the lens compares with the outstanding Summilux–M 50mm ASPH. There are eight elements in five groups with two aspherical surfaces.

Noctilux–M 50mm f/0.95 (M series effective focal length - 67mm): In 1966 Leica introduced the Noctilux 50mm f/1.2. This was the first production lens with an aspheric element and it represented a major breakthrough in the design and production of ultra high-speed lenses. The grinding process for the aspheric element was extremely difficult and expensive, and in 1976 the lens was redesigned with conventional elements. Despite its cost and size, which still limited demand somewhat, this lens continued through a number of cosmetic changes and remained available until

ummilux-M 50mm f/1.4 ASPH (M8 series ffective focal length – 67mm): This lens is comonly acknowledged as the new benchmark for higheed 50mm lenses. The image quality—even at full erture—is remarkable, with excellent rendering of fine tail and superlative bokeh. A floating element, hereby one group of lenses moves independently as e lens is focused, has been incorporated in order to aintain performance at closer focusing distances. In dition to the optical design skills required to hieve the desired image quality, the precision echanical engineering needed to incorporate everying within the constrictions imposed by an M lens ount was a major achievement.

e image quality at f/1.4 is better than the Summicron f/2. At f/2 and f/2.8, the Summilux is ahead but from 4 onwards there is little practical difference. The mmicron does, however, have slightly less distortion. e price of the Summilux is almost double that of the mmicron, which shows the cost of a one-stop gain in eed! This lens has eight elements in five groups with e aspherical surface.

A Lady at an Exhibition. 50mm f/1.4 Summilux-M ASPH. Considerable patience was needed waiting for the crowds to move and allow me a clear shot. ISO 640.

Summicron-M 50mm f/2 (M8 series effective focal length – 67mm): The very first Summicron of 1953 substantially raised the benchmark for image quality in fast 50mm lenses. It represented a major achievement by the Leitz optical design team, using new types of glass developed in Leitz' own laboratory. The current Summicron is the fourth in the line, and despite now being a relatively old design, the image quality is exceptional. It still ranks among the best available at this focal length. It is also very economically priced—so much so that Leica has concluded that redesigning it would only result in very small improvements in performance, and with a considerable increase in cost. The close range performance is very good, and the lens is lighter and more compact than the Summilux. There are six elements in four groups with no aspherical surfaces.

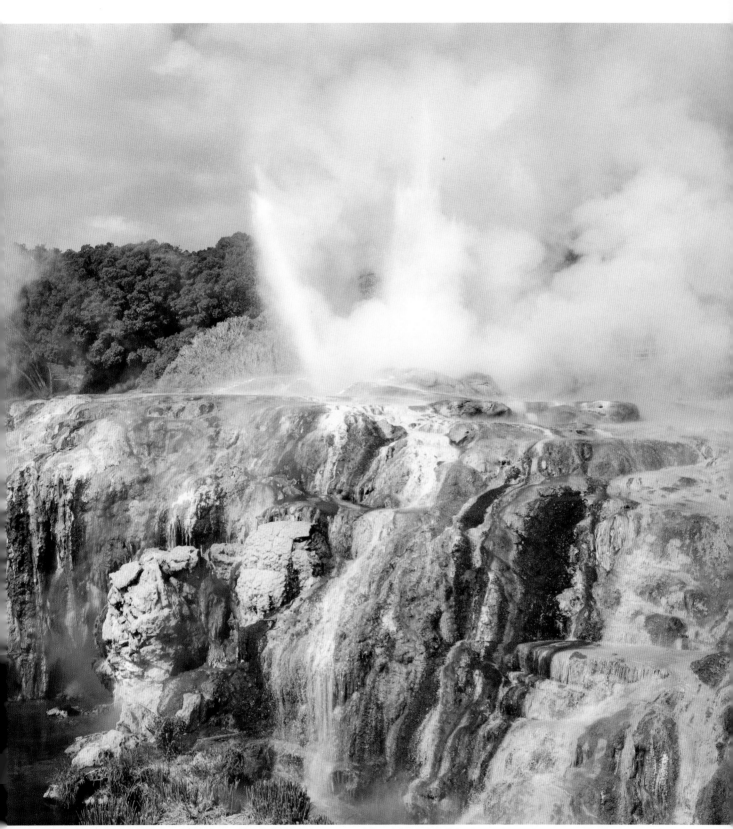

otorua, New Zealand. 50mm f/2 Summicron-M. The Summicron series of 50mm lenses has set enviable levels of erformance over many years.

Summarit-M 50mm f/2.5 (M8 series effective focal length – 67mm): The optical design of this lens has many similarities to the Summicron and it performs almost as well. The nearest focusing distance is slightly reduced to 31.5 inches (80 cm). It is the most compact and the lightest of the 50mm lenses and is very economically priced. There are six elements in four groups with no aspherical surfaces.

Telephoto Lenses

The classic telephoto lens for the Leica M has always been the "neunzer," the 90mm. This focal length provides an ideal perspective for head-and-shoulder portraits and for concentrating on the essential elements of other subjects without too pronounced a telephoto effect. With the M8, this role has been taken over by the 75mm lenses, which have an effective focal length of 100mm with this camera. The increased effective focal length of the 90mm lenses provides a fast 120mm and an opportunity with the Macro-Elmar to fill the frame with even smaller subjects.

Apo-Summicron-M 75mm f/2 ASPH (M8 series effective focal length – 100mm): This lens is a development of the outstanding 50mm ASPH Summilux design. It uses the same floating element to maintain corrections in the near range, as well as similar advanced optical glasses. The image quality is such that some respected commentators consider it to be one of the very best lenses available for the 35mm camera format. It is compact and light, especially when compared with the predecessor 75mm Summilux. The performance at f/2 is outstanding; stopping down provides only minimal improvement and is only necessary if increased depth of field is required. There are seven elements in five groups with one aspherical surface.

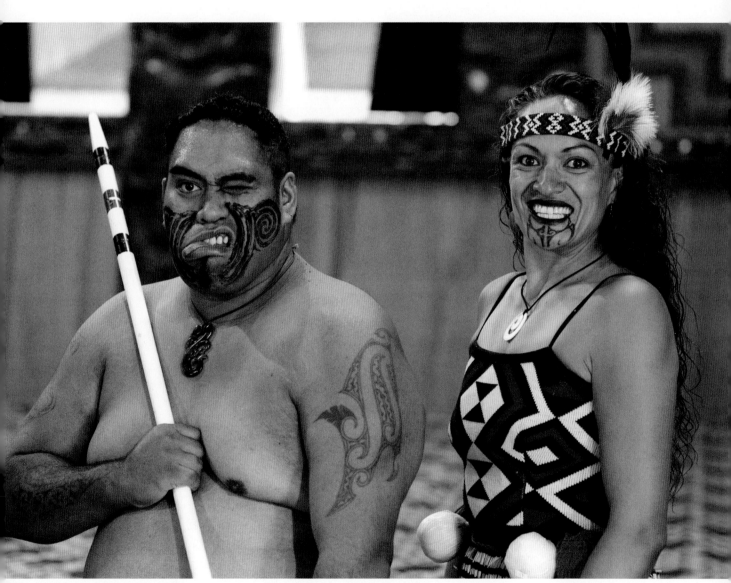

aori performers. 75mm f/2 Apo-Summicron-M ASPH. Available light at ISO 640 and f/2. This is a quite exceptional lens.

Summarit-M 75mm f/2.5 (M8 series effective focal length – 100mm): This lens is an excellent performer. Even at maximum aperture, it is very good and by f/5.6, it is almost equal to the remarkable 75mm Summicron. There is some reduction in quality in the close range, which is limited to 35.43 inches (90 cm), compared with the 27.56 inches (70 cm) of its faster brother. There are six elements in four groups with no aspherical surfaces.

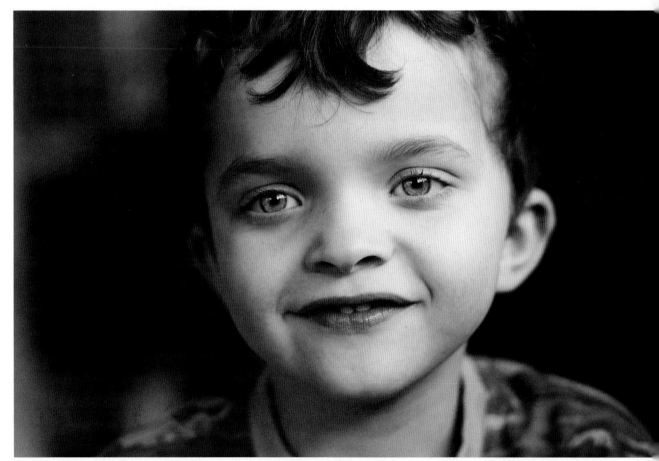

Barney. 75mm f/2.5 Summarit-M. Despite its lower price, the Summarit is a very good performer indeed. Taken at f/2.5, window light and ISO 640.

Shotover Canyon Jet Boat, New Zealand. 90mm f/2 APO Summicron-M ASPH. Another of Leica's very best lenses.

Apo-Summicron-M 90mm f/2 ASPH (M8 series effective focal length – 120mm):

Before Leica describes one of their lenses as APO (Apochromatic), it has to perform extremely high levels of correction. This lens certainly meets the highest criteria and the image quality is remarkable, with exceptional contrast and resolution of fine detail. Full aperture performance is outstanding across the whole frame. There is only a minimal improvement apparent as the lens is stopped down, so that for all practical purposes this is only necessary for increased depth of field. An effective 120mm focal length with an aperture of f/2 provides an opportunity to exploit a narrow zone of sharp focus for creative composition.

The aspheric surface on one of the lens elements is larger than could be produced by the blankenpresse process used for the smaller diameter aspherical lens surfaces and Leica had to develop special computer controlled grinding machines to achieve the required contours. There are five elements in five groups with one aspherical surface.

Summarit-M 90mm f/2.5 (M8 series effective focal length – 120mm): The previous version of the 90mm f/2.8 Elmarit-M was a favorite of many photographers. The performance was excellent and it was seen as an economical and very viable alternative to the outstanding Apo-Summicron ASPH. The Summarit is a worthy successor. It is noticeably lighter and more compact than the Summicron with very good performance at f/2.5, becoming excellent at f/5.6. There are five elements in four groups, with no aspherical surfaces.

Macro-Elmar-M 90mm f/4 (M8 series effective focal length – 120mm): Close-up photography is a difficult pursuit with rangefinder cameras, so the Macro-Elmar is a serious attempt to provide some capability for the M series cameras. The lens itself focuses down to 30.31 inches (77 cm), encompassing a subject area of approximately 5 x 7.5 inches (120 x 180 mm) with the M8. With the Macro-Adapter (very similar to the Sooky M adapter for the early models of the 50mm Summicron) the minimum subject area possible is approximately 2.2 x 3.3 inches (54 x 81 mm).

A collapsible mount similar to the 50mm f/2.8 Elmar i incorporated so that the lens is very compact and easy to carry. Image quality is excellent throughout the focusing range but it is particularly good at closer distances, as the lens has been optimized for nearer subject matter. Depth of field is very limited at short distances, so focusing has to be especially accurate. It is recommended to use the 1.25x viewfinder magnifier with this lens. There are four elements in four groups.

ose, 'Elizabeth'. 90mm f/4 Macro-Elmar-M ASPH. This lens offers a very convenient close up facility for M series cameras, pecially when used with the Macro-Adaptor-M.

Apo-Telyt M 135mm f/3.4 (M8 series effective focal length – 180mm): The M8 is not set up for this lens. Due to reduced magnification of the viewfinder and the tiny size of frame required for the effective focal length of 180mm, Leica considered that focusing and framing accuracy would be inadequate. However, if you already own one of these lenses and are careful with the focusing, the framing problem can be overcome either by judicious mental adjustment of the smallest (effective 120mm) frame or a suitably modified separate finder.

You will be rewarded with images of the highest quality. This lens has been rated as one of the best in the M range. Like the 90mm Apo-Summicron, the performance across the whole image area at full aperture is outstanding, with only minimal improvement upon stopping down. There are five elements in five groups with no aspherical surfaces.

...terham 7 at Donnington. 135mm f/3.4 APO-Telyt-M. Although not recommended by Leica for the M8/M8.2 (there is no ...ghtline frame), this lens can be used if care is exercised when estimating the framing and when focusing.

Other Lenses for the Digital M

Early Leica M Lenses

With very few exceptions, every M lens manufactured since the first M camera was introduced in 1954 will fit the M digital models. Lenses that cannot be fitted are the 15mm Hologon f/8, the dual range (close focus) Summicron, and the 1954-1968 version of the 90mm f/4 Elmar that has a retractable mount. The later (2004-2007) mm f/4 Macro-Elmar, which also has a retractable mount, can be used safely. Other than this Macro-Elmar, any lenses with retractable mounts should preferably be used only with the mount fixed in the extended position in order to avoid damage to the camera interior. Some very early 35mm f/1.4 Summilux lenses will not fit but, if required, these can be suitably modified at a Leica Service Center. The 21mm f/4 and the 21mm f/3.4 Super Angulons as well as some early mm Elmarit lenses (serial numbers prior to 2314921) will fit, but will not meter correctly because the very protruding rear element partially obstructs the metering cell. There will also be increased vignetting due to the increased obliqueness of the peripheral rays reaching the camera sensor. Many of the earlier lenses can also 6-bit coded to make them compatible with all of the current Digital M features (see appendix D).

Care has to be exercised when using some older lenses. The 21mm f/3.4 Super Angulon shown here has rear elements that protrude deep into the camera body and partially obscure the exposure meter causing false readings. © Brian Bower

Furthermore, a number of excellent, recently discontinued lenses may still be available new on dealers' shelves as well as on the second-hand market. These are certainly worth considering. They may not be coded, but do not be put off if a potentially useful lens lacks this feature. It can easily be updated and a reduced price due to its relative obsolescence should offset the cost of this.

As a lens for travel photography the 28-35-50 Tri-Elmar ASPH is a very practical option. This shot of the Sheriff at Pioneer Historic Park near Phoenix was taken with the lens set at 50mm.

Tri-Elmar–M 28-35-50mm f/4 ASPH (M8 series effective focal length – 37-50-67mm): With the M8 models, the Tri-Elmar allows a very useful choice of focal lengths—effectively 37-50-67mm. The camera's range of faster ISO settings makes for a very versatile combination, despite the restriction of a maximum aperture of f/4. The optical quality is excellent at all three focal lengths, even at f/4; and in most practical situations, by f/5.6 or f/8, I doubt that it would be possible to distinguish the results from those obtainable with the equivalent prime lenses. The later version, which can be distinguished by the E49 filter mount and the depth of field engravings, is mechanically improved. The first version is optically identical but extra care has to be taken to ensure that it locks positively into each focal length setting with the correct brightline frame appearing in the viewfinder.

e Noctilux lenses have taken on something of an icon-
character. This is the last variation of the f/1 version,
cently discontinued in favor of an f/0.95 ASPH redesign
eica photo).

**octilux 50mm f/1 (M8 series effective focal
ngth – 67mm):** Another recent deletion from the
rrent listings that must be mentioned, this lens was a
chnological tour-de-force when first introduced in
76. The designer Walter Mandler managed gains in
th the speed and optical quality compared with its
.2 predecessor, itself a landmark lens that was Leica's
st to include aspherical elements. Without using these
ry expensive aspherical elements, he produced a lens
nowned not just for its performance but also a special
keh effect. There is significant vignetting at full aper-
re but otherwise the image quality is very good and
comes even better as you stop down. By Leica stan-
rds, it also produces above-average barrel distortion,
t this lens was never intended for architectural pho-
graphy. A point to watch for is that there is a slight
us shift on stopping down. However, this is well
thin depth of field tolerances and is unlikely to be
nificant in the kind of photography for which this
s is likely to be used.

**Elmarit-M 135mm f/2.8 (M8 series effective
focal length – 180mm):** For a long time, Leica pro-
duced this lens for the M2, which also did not have a
brightline frame for the 135mm lenses. You'll recall
from the discussion of the 135mm APO-Telyt-M in
Chapter 3 that such focal lengths are not recommended
with the M8 because the lack of a corresponding
brightline frame results in rangefinder accuracy below
the required standard. With this earlier lens, however,
there is a solution! The Elmarit came equipped with a
viewfinder front attachment that magnifies the viewing
image 1.5x, so that the M2's 90mm frame was suitable
for the 135mm focal length. In the case of the M8
series, this lens is, of course, effectively a 180mm.
Although the effective base-length of the rangefinder is
also increased by 1.5x, care is still needed in focusing.
There were two optical design versions of this lens. The
later, improved design can be identified by a change in
the size of the filter mount from a series VII to E55.
Although not equal to the APO-Telyt, or even the Tele-
Elmar that was produced contemporaneously with them,
both lenses are very good performers and it is worth
searching one out if you require the longer reach for reg-
ular use. Although not shown on the official Leica list,
this lens can be 6-bit coded and the EXIF data correctly
indicates that a 135mm f/2.8 lens has been used.

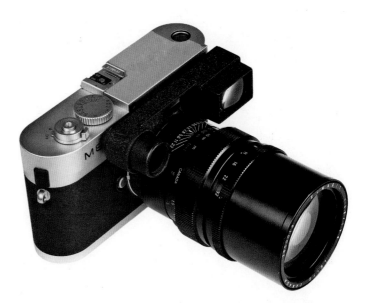

The 135mm f/2.8 Elmarit uses a built-on optical attachment to
magnify the viewfinder image 1.5x so that the 90mm frame pro-
vides the correct angle of view. It is a very practical option for the
M8/8.2 as the improved effective rangefinder base length magnifi-
cation is sufficiently accurate for this focal length.

A 135mm Elmarit shot. The 180mm effective focal length is extremely useful for action subjects. © Tony Godwin

When comparing lenses from earlier periods to the latest designs, the general rule is that the development of advanced glass types, the incorporation of aspheric lens elements, and the improved coatings now used have all enabled designers to achieve higher contrast, better edge definition, and better control of flare—especially at the widest apertures. In some cases, this has also helped to produce more compact lenses. This is important with Leica M lenses in order to minimize intrusion of the lens mount into the corner of viewfinder brightline frames and to maintain the overall compactness of the system.

There was a belief at one time that, compared with some other manufacturers, Leica optimized resolution in favor of contrast. With film, high contrast is important. This may be less so with a digital sensor where the dynamic range is more limited and post-processing on the computer can selectively adjust image contrast. One of my all-time favorite 50mm lenses is the second series Summicron produced from 1957 to 1969. Although later Summicrons are technically superior, with

some subjects I love the general image quality of this le and I find that it works nicely with the digital sensor of the M8. It might lack the contrast and biting sharpness of the 50mm Summilux ASPH that I normally use, but the is a delightful luminosity that is especially apparent in some of the earlier Leica lenses.

Generally speaking, any earlier Leica lens from the six ties or later will, if in good condition, produce very good image quality. Later advances in design and man ufacturing technology have probably benefited the wide-angle lenses most, but this is primarily seen with image quality at the edges of the frame at the wider apertures. By f/5.6 or f/8, the gains are less obvious a for most purposes insignificant.

See Appendix F for a listing of earlier M lenses with dates and details.

Screw Mount Leica Lenses

rior to the introduction of the M, Leica used a screw mount for their lenses. Some screw mount lenses were roduced until the mid sixties with the later ones incorporating the same optical formulae as the contemporary M lenses. With an appropriate screw-to-bayonet dapter, these lenses can be fitted to the M8. It is an mazing tribute to long-term compatibility that a lens rom a 1932 Leica II can, with an adapter, be fitted to ny current Leica M body. Genuine Leica adapters can nly be found second hand but there are third party fferings available, e.g., from Cosina-Voigtlander. Whether buying new or second hand, make sure that ou get the correct one for your lens in order to bring p the correct brightline frame in the viewfinder. The

same general comment with regard to the lens quality of earlier versus current lenses applies to the screw mount ones. There is also, of course, the greater likelihood of deterioration and wear and tear over the years. And, don't forget to mount lenses with a retractable mount only in the extended position!

There is a listing of the Leica screw mount lenses at Appendix H.

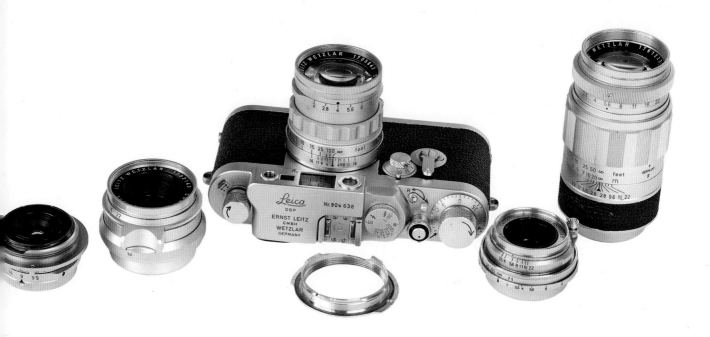

efore 1954's introduction of the M3, which featured a bayonet mount, all Leicas with interchangeable lenses had a screw ount. This picture shows the last screw mount Leica model, the IIIg, with a collection of its contemporary Leica lenses and a mm f/3.5 Canon lens that has the same standardized fitting. In the center foreground is an example of the screw-to-bayonet apter that enables screw mount lenses to be used on an M camera. © Brian Bower

Valerie. The rigid chrome 50mm Summicron from 1967 was the lens used here.

The Visoflex Lenses

The Visoflex was developed in the days before SLR cameras became popular. It converted the Leica into a reflex camera, enabling both close-up photography and the use of lenses with greater focal lengths than 135mm—the longest that could be coupled accurately to the rangefinder.

There were two versions specifically developed for the M cameras: The Visoflex 2 and the Visoflex 3. The main difference is that the Visoflex 2 has no auto-return mirror. This has to be reset each time a photograph is taken, which is not ideal for action photography with a long telephoto lens! There is a pentaprism-type eyelevel finder piece, which is exchangeable with a vertical finder. Unfortunately, the Visoflex 2 type eyelevel finder cannot be used with the M5, M6 TTL, M7, or the M8 models because it fouls the top plates of these cameras. There is no problem with the vertical finder, and the Visoflex 3 type eyelevel finder can be used with Visoflex 2.

There are a number of interesting lenses that were mad especially for the Visoflex system and many of the ea: lier rangefinder lenses can have their lens heads removed and fitted to the different focusing mounts that are needed to allow clearance for the mirror system. There is no auto-diaphragm mechanism with any lenses on the Visoflex, although some have pre-set diaphragms so that you can focus at full aperture and then stop down quickly to the preset working aperture There is also an excellent bellows unit that (with adapters) accepts many lenses. It allows the possibility of close-ups to larger than life size.

Compared with the convenience of a modern SLR, eve a late model Visoflex is clumsy and slow in use. If yo wish to try one with your M8 and thereby have acces: to some interesting lenses, I would recommend the Visoflex 3. As for lenses, the 65mm Elmar (equivalent 87mm with the M8) is probably the most versatile. In the normal 16464 Universal Focusing Mount, it will enable you to focus to a ratio of 1:3; and if used on t

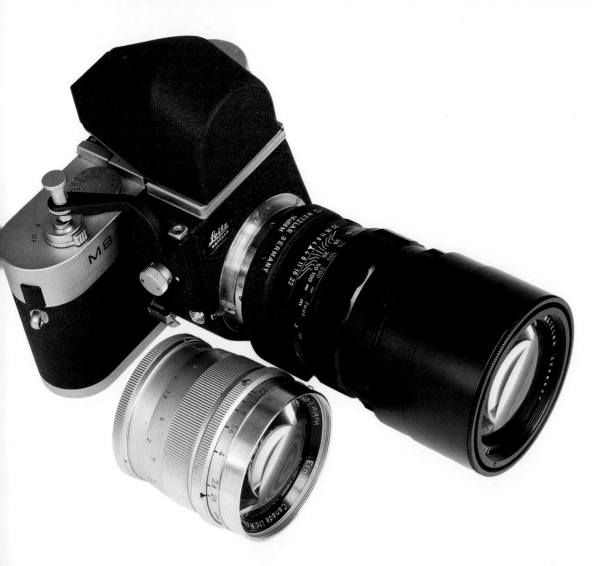

he Visoflex is a reflex housing developed by Leica to convert the M (and also, with earlier versions, the screw mount eicas) into an SLR for long lens and close up photography. This is a very late version, the Visoflex 3, together with two assic Visoflex lenses: the 200mm f/4 and 125mm f/2.5.

ellows unit, you can capture up to 1 1/2 times life ze. The 200mm f/4 and 400mm f/6.8 (respectively quivalent to 266mm and 533mm on the M8 models) are ry good; the 400mm is especially light and convenient use for sports and wildlife photography. The 125mm 2.5 Hektor (equivalent 167mm) is a fascinating lens for ortrait work. It gives lovely effects at full aperture.

ven with careful adjustment of the shutter-opening m, the TTL metering on the M8 is not really fast ough to achieve an accurate auto reading after the irror has lifted and before the shutter starts to run. anual setting of the exposure is more reliable. This n be done with the mirror temporarily raised and ecking in the camera viewfinder or by using a sepa- te exposure meter.

The Visoflex is not a rare item and if you are tempted to try this very interesting piece of equipment and its lenses, you can often find them at specialist Leica dealers or on eBay. Don't forget that you will need to mask the viewfinder in order to adjust for the narrower viewing angle of the M8.

A listing of the Visoflex lenses can be found at Appendix I.

When buying second hand do your homework. Each of these 50mm lenses may bear the Summicron name, but there is 40 years and considerable optical improvement between the 1953 version on the left and the current version on the right. © Brian Bower

Buying Used Lenses

You may well find recently discontinued lenses still new on the dealers' shelves. These will obviously still have a full warranty and may be sold at a worthwhile discount. Naturally, you must be more careful when buying used lenses, but there is a thriving second-hand market and there are plenty of bargains to be had. If you are on a strict budget, it is worth looking around.

The first step is to know exactly what you are being offered. As an example, there have been four different optical designs of the 50mm Summicron as well as several cosmetic changes. The serial number will give you an indication of the lens' age. The listing of earlier lenses in the appendices of this book will then help you to identify which version it is likely to be. In addition to some very helpful information available from illustrated collectors books, there are also price guides available. A study of dealer listings on the Internet will also give you a good idea of an appropriate price.

Having identified the lens, look for any physical damage. Especially check the surfaces of the front and rear elements of the lens. A 5x or 8x magnifier helps. You can use a 50mm lens for this if need be! A tiny scratch or mark will be of little consequence, but a dulled surface caused by over-enthusiastic cleaning can seriously reduce contrast and increase flare. With the mount, slight scuffs and marks are inevitable if a lens has had any real use, but more serious damage could be an indication of potential internal problems with misaligned lens elements or the rangefinder cam adjustment.

Check that there is no obvious damage to the diaphragm blades and that they are not contaminated with oil. This and/or damaged screw heads is an indication of inexpert servicing or repairs. Look at the inner elements, a few specks of dust are of little importance, but any indication of condensation or misting could be a source of problems. See that the lens stops down

noothly and that the click stops are not too free or too
iff. Older lenses, by the way, only click in at full stop
tervals—not half stops as is usual with later lenses.

ie focusing should be smooth and not too stiff.
owever, if a lens has had little or no recent use, it is
ely to be slightly stiff. Operate it over the full focus-
g range a few times and it should get freer. It is pos-
ble on an older, infrequently used lens that the lubri-
nts have dried out and a service (not cheap!) may
en be needed.

t the lens to the camera and check with the viewfind-
that it focuses correctly at infinity. Choose a subject
least 400 yards away to do this test. Take some pic-
res at close distances—3 to 10 feet (1 to 3 m). Use full
erture, and focus very carefully. Use a tripod or a
gh shutter speed in order to avoid camera shake.

Then, on the viewing screen, use the highest magnifica-
tion to check that the focus is accurate. If all is well,
you are now ready to negotiate!

As a rule, most Leica users take good care of their
equipment, so it is often possible to find items in very
good condition at sensible prices. Be warned, however,
that truly mint items are often collectors' territory and
priced accordingly!

Third Party Lenses

After the Second World War, German companies forfeited their patent rights. Many other manufacturers began producing cameras and interchangeable lenses using the standard Leica L39 screw mount. This included some notable names such as Canon. Also, when Leica discontinued the manufacture of screw mount lenses, others moved in to fill the gap. As a result, there are many early third party screw mount lenses on the market. Some of these were very good performers in their day.

Recently, Cosina introduced a series of new Voigtlander rangefinder cameras with an extensive range of lenses that also use the Leica L39 mount. These lenses are very economically priced and the range includes a number of focal lengths (especially in the ultra-wide angle range) not covered by Leica itself. The same company makes screw-to-bayonet mount adapters to allow use on cameras with the M-type bayonet. Some of the lenses are also available in an M bayonet mount, thus obviating the need for an adapter.

For a period in the 1970's, Leica co-operated with Minolta to produce the compact Leica CL camera (known as the Leitz-Minolta in Japan). This used the M bayonet and was available with a 40mm f/2 Summicron and a 90mm 4 Elmar. Because the rangefinder cam was considered to be less precise than that on the standard M, these lenses were not recommended for use on M cameras. Minolta, however, went on to develop the CL into the Minolta CLE. The CLE system also included a very nice little 28mm f/2.8 Rokkor lens and the cam was similar to that of the normal Leica M lenses. However, the Minolta 28mm does not bring up the correct brightline frame in either the M film cameras or the M8 series. If you do want to use one of these lenses, you will need a separate finder.

More recently, Zeiss has designed a range of M-mount lenses. Two of these are made in Germany (the 15mm and the 85mm) the others are manufactured in Japan. The German-made lenses are very expensive; the others are more economical, although still somewhat higher priced than the Voigtlander range.

Be aware that no third party lenses are 6-bit coded. Also, the caveats mentioned above regarding the dangers of fitting lenses with retractable mounts (or those with protruding rear elements) apply.

...lesfield Canal. Taken with the classic 50mm rigid chrome Summicron. This lens has very pleasant tonal qualities and is highly respected by M aficionados.

...eiss and Voigtlander also offer a range of clip-on ...ewfinders for their lenses. In addition, Voigtlander has ...number of minor accessories that are useful as sup-...ements to Leica's own somewhat limited range. There ...e other makers of useful items, too. Surf Leica and ...lated sites on the Internet and you will find enough ...keep you interested for days!

As a final proviso, I do need to mention that Leica can-not endorse the use of third party lenses and acces-sories on their cameras and you need to be aware of potential warranty problems! Nevertheless, there is evi-dence from Internet forums that there are many pho-tographers who find them satisfactory with respect to compatibility and performance.

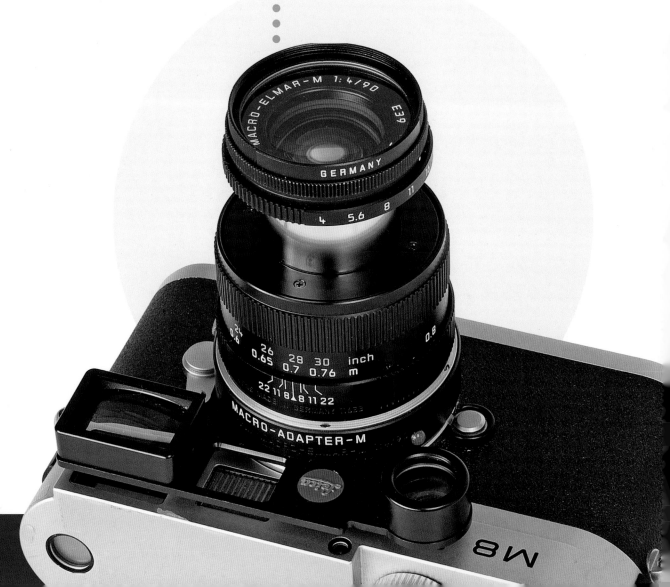

Accessories for Leica M Digital Cameras

Compared with SLR systems, a rangefinder camera has a much more limited field of applications. The M series is no exception, so there is no requirement for a large range of accessories. Nevertheless, there are a number of useful—in some cases essential—accessories that should be considered.

Accessory Viewfinders

The brightline frames of the M8 series provide for focal lengths from 24 to 90mm (effective 32 to 120mm). To cover the 21, 24, and 28mm focal lengths that are effectively provided by the 16 – 18 – 21mm Tri-Elmar and the 28mm focal length provided by the 21mm Elmarit ASPH, you will need a separate viewfinder. The currently available options are:

Universal Wide Angle Finder M:The disadvantage of this finder is that it is not very compact. This is because it has quite a complex optical construction with an aspheric element. There is also a bubble level, which is projected into the viewing frame. This is particularly useful with ultra-wide angle lenses if it is nec-

essary to ensure exact alignment and avoid converging or diverging verticals. There is also a facility for parallax compensation from infinity down to 1.6 feet (0.5 m). Leica sells this finder as an optional package with the Wide-angle Tri-Elmar, which offers a worthwhile savings over the combined price of buying each item separately.

Leica Viewfinder M for 21-24-28m lenses: The earlier 21-24-28mm viewfinder is a much more compact option that provides for the focal lengths not able to be included in the M8's built-in viewfinder. Both finders can be fitted with diopter correction lenses.

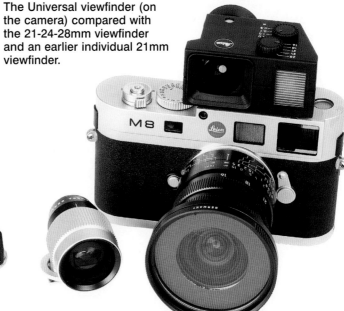

The Universal viewfinder (on the camera) compared with the 21-24-28mm viewfinder and an earlier individual 21mm viewfinder.

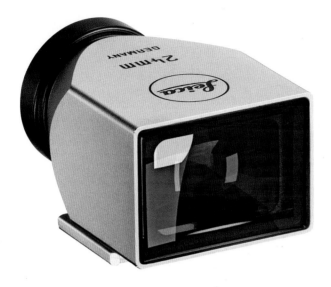

Viewfinder Magnifier M (1.25x and 1.4x)

It is sometimes helpful when working with the longer focal lengths (above 50mm, say) to have an opportunit to magnify the viewfinder image. This enables more accurate focusing and more carefully detailed composi tion of the image. There are two magnifiers available. One has a magnification of 1.25x and a newer model offers 1.4x. They are both particularly helpful when using the 90mm lenses. This is especially true of the 90mm Macro-Elmar M when working on close-up sub jects. In these situations, precise placement of the poin of focus is necessary in order to make best use of the very limited depth of field. Remember, however, it is not possible to see the brightline frames for lenses wit a shorter focal length than 50mm with the 1.25x and 75mm with the 1.4x.

Individual Brilliant Viewfinders: A third option, which I prefer when I want to travel light, is to use one of the individual viewfinders. These were at one time available for 21, 24, and 28mm focal lengths with designs that varied over the years, but were eventually discontinued. At Photokina in 2008 Leica introduced two new designs for the 21 and 24mm focal lengths only. These are suitable for use on the M8 series cameras when the Tri-Elmar is set to 16mm or 18mm. They are beautifully made with a metal body milled from solid brass, finished in either silver-chrome or black paint. They incorporate an optical construction that shows the picture area outlined as a bright frame with parallax markings for distances below 6.6 feet (2 m). I mostly use the Tri-Elmar set at 16mm (effective 21mm on the M8), so for this I use a 21mm viewfinder (actually an older model that I have had for some years). While using the 28mm effective focal length, I assume that the whole of the area of the M8 viewfinder is the equivalent. This is an old M trick, and not too bad a guesstimation.

Angle Finder

This is a useful accessory that allows more comfortabl viewing of subjects close to the ground (e.g., close-up of plants or insects) and for copying or other reproduc tion work, where the camera is pointed downwards. It shows a laterally correct, right-side-up, circular section of the center of the image, approximately 0.33 inch (8 mm) in size. There is a 45° angled and rotating sight t facilitate a comfortable viewing angle.

Macro-Adapter-M

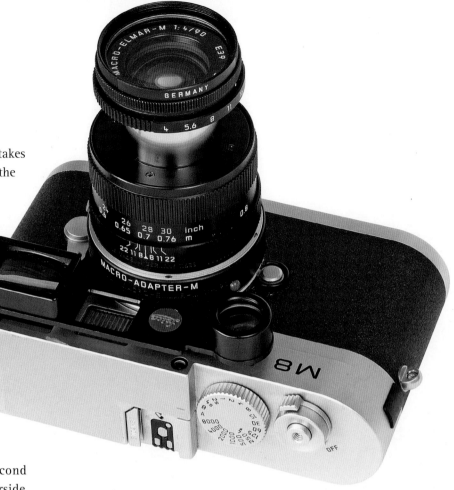

The 90mm Macro-Elmar normal focusing range takes to 0.03 inch (0.77 mm). At this distance, with the 8, the minimum object field is approximately 72 x 7.09 inches (120 x 180 mm). With the acro-Adapter-M attached, the minimum cusing distance is 1.6 feet (0.5 m) and e minimum object field is 2.13 x 3.19 ches (54 x 81 mm). This is close ough for many interesting macro bjects, including things like but- flies and small flowers. As well adjusting for the near focusing nge in the manner of an exten- n tube, the viewfinder image is rther compensated for parallax at ese distances.

r this near range, the 90mm Elmar has a second stance and depth-of-field scale on the underside. ter the adapter has been attached to the camera, e lens is then mounted to it with the underside w facing upwards.

A Fly Agaric fungus photographed with the 90mm Macro-Elmar.

The Port of Rotterdam, shot with the Tri-Elmar-M at 28mm.

Leica SF24D TTL Flash

This unit has been specifically designed for Leica cameras. When it is set to TTL/GNC the M8 achieves effective TTL flash metering via a preflash. Normal TTL flash metering is available for the M7 (or M6 TTL). For other M cameras with a contact in the accessory shoe, auto (computer control) function or manual operation is possible. The normal angle of illumination covers the 28mm effective focal length but a supplied diffuser increases this to 24mm and a telephoto adapter narrows the normal angle and concentrates the light to provide the maximum guide number for 85mm or longer.

Fill-in flash options with this flash unit are particularly easy to use with the M8 (see chapter 7). It takes up only a little extra space in the gadget bag and is well worth including in an outfit. The Metz Company, who makes the SF24D for Leica, has a very good range of flash units which comply to the SCA 3002 standard. Several units are compatible with the M digital cameras when they are fitted with the correct SCA 3502 adapter. These offer more power and versatility than the SF24D, should they be necessary.

Filters

Filters are especially important accessories for the M8 cameras. As we have discussed earlier, in the process of creating a digital camera within the constraints of the compact M body with its lenses of comparatively short back focus, the Leica engineers had to compromise on the thickness of the infrared and anti-aliasing filters that sit in front of the CCD sensor. Their prime objective was to maintain the high quality optical performance of the Leica M lenses.

The occasional aliasing problems (moiré) can usually be dealt with by post-processing in the computer, but the magenta cast that can occur on clothing with synthetic materials or other situations affected by high infrared reflectivity is more easily dealt with by putting a filter on the camera lens.

The UV/IR Leica filter has been specially designed to match the requirements for the M8 sensor and can be left permanently fitted to a lens if required. Many photographers (the author included) regularly keep a UVa skylight filter on a lens if only for protection from rain, snow, dust, and sticky fingers so changing this for the UV/IR is not a problem. However, it is important to remove this filter if you are shooting with a film camera.

Leica does say that when using the UV/IR filter, ideally the lens should be 6-bit coded and enabled in the camera (see Chapter 2). This allows the firmware to compensate for any possible edge effects in certain situations. It should be noted that there are IR filters available from suppliers other than Leica, but the light transmission characteristics of these are not specifically matched to the M8 sensor.

An Infrared image made with the 28mm Summaron lens and an old Leica infrared filter.

It is possible to exploit the infrared sensitivity of the M8 sensor to create interesting images by blocking all or part of the visible light component of the spectrum instead of the invisible infrared. B+W supplies two suitable filters, the IR 092 and 093; the first allows just a small amount of visible light to pass, whereas the second is more opaque and allows only infrared. There is a significant reduction in total light passed by the filters so that an increase in the ISO speed setting will be required to keep exposures sufficiently short for hand-held photography. The focus point of the image will also shift. The lens needs to be focused to a nearer distance than for visible light. This adjustment will vary with individual lenses and will need to be established by trial and error. A useful starting point is to focus with the rangefinder and then focus closer by moving the distance setting to the f/5.6 mark on the depth of field scale. Some older Leica lenses have an IR focusing mark engraved on the depth-of-field scale.

Leica also supplies a polarizing filter for the M series cameras. This has adapters for 39mm, 46mm, and 49mm threads. Due to the need to first view the effect via the viewfinder and then take the picture through the lens, this is a somewhat cumbersome device. It involves a mounting that allows you to swing the filter 180° to its position in front of the lens after first checking the setting through the viewfinder.

Filter Sizes of Popular M Lenses

Filter	Lenses
39mm	28/2.8 Elmarit-M, 35/2 Summicron-M, 50/2 Summicron-M, 50/2.8 Elmar-M, 90/4 Elmar-M, 35/2.5 Summarit-M, 50/2.5 Summarit-M
46mm	24/3.8 Elmar-M, 28/2 Summicron-M ASPH, 35/1.4 Summilux-M ASPH, 50/1.4 Summilux-M ASPH, 75/2.5 Summarit-M, 90/2.5 Summarit-M, 90/2.8 Elmarit-M
49mm	28-35-50 f/4 Tri-Elmar-M ASPH, 75/2 APO Summicron-M ASPH, 135/3.4 APO Telyt-M
55mm	21/2.8 Elmarit-M ASPH, 24/2.8 Elmarit-M ASPH, 90/2 APO Summicron-M ASPH
60mm	50/0.95 Noctilux-M ASPH, 50/1 Noctilux-M, 75/1.4 Summilux-M
67mm	16-18-21/4 Tri-Elmar-M ASPH (with special filter mount)

Note: the tables of earlier Leica lenses in Appendices F and H show filter sizes.

Tripods

A tripod is almost a contradiction for the highly portable, ready for action, Leica M, but there are occasions when one is necessary. There is a wide selection of high-quality, full-size tripods available from various manufacturers. The choice is very much a matter of personal preference and budget. For studio type applications and occasional outdoor close-up photography, I use an old Benbo. It is fitted with the large Leica ball-and-socket head. The Benbo is a rather idiosyncratic device but it does have great flexibility for positioning, so that if need be you can get down to ground level. It is built like a tank, is as solid and stable as you can get within reason, and is correspondingly heavy! So unless I have some special reason, this tripod stays at home or in the car trunk.

I do, however, regularly carry the Leica Tabletop Tripod. It is light and compact, but very rigid. For compactness it is fitted with one of the old Leica small ball and socket heads (you will have to hunt for one of these second hand) and when folded up it can be fitted easily into a gadget bag. It is very useful for night shots or other low light scenes where you can find some suitable object to place it on or brace against. The use of a full size tripod not only draws attention, but is banned in some public places and buildings, whereas the table tripod is much less noticeable. Be warned however, that the folded device could resemble a revolver to an airport security x-ray operator, so be prepared to demonstrate it if necessary!

Cases

Ever Ready Cases

The Leica Eveready Case for the M8 is available in black nappa leather or black neoprene. The leather case holds the camera with a lens up to 60mm diameter and 70mm in length. A rotating lower section allows easy opening of the M8 base plate to enable quick battery or memory card changing. The back is cushioned to protect the camera's LCD display.

The black neoprene Leica Eveready Case protects the camera and uses convenient Velcro fasteners. There are also two spaces for spare memory cards. A standard front version is for lenses up to 65mm diameter and 60mm long. The Long Front model is for lenses up to 65mm diameter and 80mm long.

There is also a leather half-case called the Leica Camera Protector that protects the body. A gap in the back is provided for the M8 LCD viewing screen.

Outfit Cases

Not only are there many individual manufacturers, but also each one of them seems to offer a tremendous range of products. Let's be clear: There is no such thing as the perfect bag. What you think is ideal for you this year may be of little use next year. There is a cycle. You buy a bag, then you expand your outfit and you buy a bigger bag; then you decide that it is ridiculous to carry so much equipment around all the time and you buy something quite small to force you to carry only the essentials. Next off you plan an overseas trip and choose a bag to handle all the equipment that you think you might need. Then you realize that it is much too big and heavy for the airlines hand baggage restrictions!

At present, Leica only offers one case: The Leica Billingham Combination Bag. Made of waterproof canvas by a highly respected UK manufacturer, it will hold either two cameras and two lenses or one camera and three lenses. There is also a zipped compartment that provides space for an SF24D Flash unit and some other small accessories.

My current choice for a full M8 outfit is a medium-sized Lowepro backpack. I can fit two cameras and six lenses in the lower compartment and there is plenty of space in the top compartment for documents and accessories, including the SF24D Flash, a table tripod, and a jacket. The bag was chosen with airline limitations in mind and it forces me to stay within reasonable limits. The weight is also not too much for a sensible walking distance when it is carried in backpack fashion. I have had it in regular use for over two years and that includes three major overseas trips! It is no longer pristine and looks fairly nondescript—which is not a bad thing from a security point of view. Maybe, just maybe, this is it!

Most manufacturers have similar offerings and ideally you should try to find a dealer where you can see examples of the different bags and take along your Leica outfit to check exactly how well it fits. You also need to consider the level of protection it offers in case of rough handling and that you are able to access items reasonably easily without anything falling out.

Third Party Accessories

The range of accessories available from Leica is limited. As well as the specific items mentioned above, there are many other items from third party suppliers and manufacturers that usefully complement Leica's own offerings. A little surfing on the Internet may surprise you with the volume of hits. Be careful, however, not to compromise your Leica warranty.

Batteries and Chargers

Especially with a digital camera, a fully charged spare battery is a must. Murphy's Law says that your battery will always run out when you do not have a spare and always at the most critical moment. I have a spare for each camera plus one for good luck. I also carry a charger in my car or one in my hand baggage when traveling away from home by air. A new Leica Compact Battery Charger was introduced at Photokina 2008. This unit has an indicator to show when the battery is charged to 80% capacity, which is very useful if you are in a hurry to use the battery.

Correction Lenses

The M8 eyepiece is calibrated to -0.5 diopter. For accurate focusing and viewing of the viewfinder displays, it is necessary to be able to see clearly. If this is a problem, you can of course wear your spectacles. Eye relief in the viewfinder, however, is limited so that when you wear glasses you may not be able to see the entire image area with the wider-angle brightline frames and you may miss some of the other information displayed. There is an option to obtain correction lenses from Leica that will screw into the viewfinder eyepiece. However, the disadvantage of using correction lenses is that when you come to view the image on the rear LCD display you will likely need to put your spectacles back on anyway. Catch 22!

ew from the Sydney Tower. Tri-Elmar-M ASPH at 16mm.

Hardware and Software

Firmware

The reprogrammable part of the software that controls a digital camera's internal processing is referred to as the firmware. With more advanced cameras like the M digital models, this can be updated much the same way that computer software can be updated to include new versions, incorporating new features, or fixes for problems that have emerged. With the M8, new versions of its firmware are made available on Leica's official website, from where they can be downloaded onto an SD memory card and then loaded into the camera, overwriting the previous version. Leica's instructions for the procedure are given in Appendix B. These should be followed carefully in order to ensure trouble-free updates.

To date, the firmware versions that have been applicable to the M8 have been:

06 Installed on some very early production cameras.

09 An early update that was installed on cameras after the very first production series, and included one modifications to the first series cameras that were the subject of a recall.

092 This release incorporated several changes in the presentation of information on the viewing screen. There were also several bug-fixes and improvements to internal procedures.

102 Optimized internal procedures.

201 Greatly improved white balance and provided information for new Summarit lenses.

00 Added facility for larger SD and for SDHC memory cards, as well as AUTO ISO function.

Memory Cards

The M8 models accept the standard Secure Digital (SD) cards and, from firmware version 2.00, SDHC cards up to 32GB. Leica no longer lists tested and approved cards but they do recommend that you use known, reliable brands of professional quality including SanDisk and Lexar. I know that many people use relatively cheap cards—some seem to work just fine, others can cause problems. Given the relatively low cost of top-brand cards, to me it hardly seems worthwhile to risk potential problems with cards from some obscure source.

My choices are SanDisk Ultra II 1GB and 2GB. I have some of the same manufacturer's Extreme III cards but, in practice, there seems to be little or no advantage to using these, although they are nominally faster. Most importantly, all of my SanDisk cards have proven to be reliable over quite a long period of use.

Unless I am on a major shoot, I tend to prefer to use the 1GB cards, which allows me around 70 images if I shoot DNG + JPEG fine. This is equal to two rolls of film—or four, taking into account that I usually carry two cameras, each with its own card—without having to change cards. For many purposes, this is adequate and it makes it easier to keep track of images when downloading and cataloging them.

Wetzlar, the Alte
Brucke. 28mm f/2
Summicron-M
ASPH.

File Types

The M8 allows images to be saved to the memory card as DNG (RAW) files, various qualities of JPEGs, or one each of DNG and JPEG.

DNG is effectively a digital negative as produced by the sensor. There is some minimal processing but this has more to do with controlling file size than any aspects of image quality. The DNG file needs to be processed in a computer in order to produce a useable image. The various parameters of color balance, contrast, brightness, and other elements are established at this stage.

JPEGs, on the other hand, have been subject to significant processing by the in-camera processor so that a useable image is immediately available. The image that you see on the viewing screen is a JPEG. The files are compressed with either a [fine] or a [basic] option, and the resolution can be set by choosing the maximum of 10MP, or the 6, 2.5, or 1MP file sizes.

The number of images that can be stored on a 1GB SD memory card gives a clear indication of the information held within the different files and the quality of the image that can be produced.

You can capture both a DNG and a JPEG image at the same time. In this case, DNG + JPEG fine at 10MP resolution allows a typical storage of 70 images. This only improves to 91 images when DNG + JPEG fine at 1MP resolution are stored together, so my practice is to work with DNG + JPEG fine at 10MP resolution.

Remember that the JPEG files are compressed, and any further processing of the images will result in more loss of quality. So, when you download the files to the computer, it is best to save them in a lossless format (I use TIFF) if you intend to carry out any work on them. The DNG files are lossless, but I find that it is more convenient to work with a TIFF copy, which initially produces a file size of about 29.5MB at 8 bits or 59MB at 16 bits. If significant work is to be carried out on an image file (with Adobe Photoshop CS4, for example) it is better to work with a 16-bit file and then convert the final result back to 8 bits for printing or other purposes.

For downloading to the computer, I use a card reader rather than a direct transfer from the camera. This is more convenient, especially because downloading can make considerable demands on the camera battery. It is essential to start with a fully charged one if you do download direct from the camera. There is nothing more irritating—and worrying—than to have a download fail partway through.

Resolution	DNG	JPEG fine	JPEG basic
10MP	93	276	386
6MP	N/A	491	687
2.5MP	N/A	>1000	>1000
1MP	N/A	N/A	>1000

nrise Monument Valley with the Tri-Elmar-M at 28mm.

Image Processing Software

The software provided by Leica for downloading images to a computer is Phase One's Capture LE. This is one of the leading professional programs and it has a reputation for achieving very high quality conversion from the RAW (DNG) files that the M8 produces.

There are other excellent image-processing programs. Two that are highly regarded and popular with professional and savvy amateur photographers are Aperture 2 (for Mac) and Adobe's Lightroom (for both Mac and PC). These two are primarily for initial image downloading and processing, cataloging, and straightforward outputting to print, web, or slideshow. Any one of the above programs is capable of top-quality results. New and updated versions are regularly made available. Differences are marginal, so at any one time it is difficult to say which is best. Personal preferences together with familiarity and ease of working are probably more important than relatively minor technical advantages. Complex image manipulation requires other software. The professional standard for this is Adobe Photoshop. At the time of writing, the latest version is CS4. This has its own downloader and organizer (CS Bridge), which many photographers find perfectly sufficient for their requirements.

For less sophisticated requirements, a less comprehensive version, Adobe Photoshop Elements, is very capable. The latest versions can handle the M8 DNG files without any problems and the facilities for RAW image processing, cataloging, and subsequent manipulation are now very comprehensive and straightforward to use. Elements costs significantly less than the closely-related CS4, while still incorporating many of the features most needed by photographers.

The above are probably the best-known and well-regarded examples of image processing software. It is not the purpose of this book to cover post-camera work. That would require a book in itself—more than one in fact! There are excellent books available at www.larkbooks.com/digital that cover each of the programs mentioned above in considerable detail.

Computer Hardware

Anything written about computer hardware today will be out of date by tomorrow, so I hesitate to make even very general comments. I won't even enter into a discussion of the relative merits of Mac versus PC! Let me just say that there are pros and cons for each.

What you do need to remember is that image files are big and that handling and storing these files requires a fast processor, large working memory, a very large hard drive, and a good graphics card. Back-up capacity, too, needs to be very large. For personal use, given that the cost of hardware constantly reduces, I would be looking for a really fast processor, at least 2GB of memory, a minimum 500GB hard drive and 750GB or more of external hard drive space for back-up. If you are working professionally, you will probably consider this to be a laughably small setup and you will in any case already have a very clear idea indeed of exactly what you need.

Unless you have very good computer skills, I think that the most important consideration is to buy from a source that can be relied upon to provide you with good support. When something goes wrong, you need somebody who you can trust to help you resolve a problem quickly. For me, it's the photography that matters; the computer is a secondary tool and the easier and more reliable it is to use, the better I like it!

Opposite page. Dubai, the famous Burj al Arab hotel. 28mm f/2 Summicron-M ASPH

The Mosel Valley,
early morning near
Piesport. Taken
with the 28mm
Summicron.

Flash Photography with the Leica Digital M

ause M cameras are the ultimate instruments for available light photography, it might seem a little contradictory to talk about using flash. ~vertheless, there are times when there is no other ~tion, or when a photographer wishes to use his or her ~mera in a studio environment. There are also situa- ~ns where a little supplement to the ambient light can ~ advantageous. The M8s offer significantly more ~tions for flash photography than previous models, ~thout losing the essential simplicity of operation for ~ich the M cameras are so well known.

~ the heart of the Leica M film-based cameras, there ~s always been a traditional horizontal-running focal ~ne shutter of rubberized fabric. This shutter is ~echanically governed, (except in the M7, where it is ~ctronically controlled) and has been developed and ~fined over many years to a remarkable level of relia- ~ity and quietness. However, there were two elements ~ the design that were impossible to overcome. One ~s that the fastest reliable shutter speed was 1/1000 ~cond and the other was that the fastest synchroniza- ~n speed for electronic flash was 1/50 second. While ~ 1/1000 second maximum shutter speed was rarely a ~oblem, the low synchronization speed presented real ~fficulties for fill flash in daylight. With certain flash ~its, the M7 can be set up to synchronize at 1/250 – ~1000 second, but this can be a complicated and time- ~nsuming process.

Scarlett. A touch of flash bounced off the adjacent wall and ceiling was used to supplement the daylight.

Claret Cup Cactus, Zion National Park. Pictures taken in harsh overhead light, such as here, can often benefit from a touch of fill fla

The M8 required a different shutter so a vertically-running, multi-bladed, metal shutter was squeezed into the compact M body. The shutter, similar to that of the Leica R9, provides a top speed of 1/8000 second on the M8 and 1/4000 second on the M8.2. The fastest synchronization speeds are respectively 1/250 and 1/180 second. This is high enough for almost any fill flash requirement, and there are various options available within the digital menu that have considerably simplified this technique.

Viewfinder Information

With compatible flash units, the M8 and M8.2 in both Manual and Auto (aperture priority) modes, as well as S mode in the M8.2, give an indication in the viewfinder that the flash unit is adequately charged and ready for use. This is shown by a continuous glow of the flash symbol (a lightning bolt).

After the exposure has been made, there is an indication that enough light was available if the symbol continues to glow or to flash briefly before it goes out. The flash unit is not ready for another exposure until it starts to glow continuously again.

M–TTL Flash

With suitable flash units, the cameras also incorporate a form of TTL (through-the-lens) flash metering. With a film camera, the flash is controlled by a cell that meters off of the surface of the film during the exposure. This is necessary, of course, because the flash can only be measured as the exposure actually takes place, and not in advance, as is the case with ambient light. It is not possible to meter off the surface of a digital sensor, so the digital M fires a pre-flash, which is then measured off the shutter by two cells on either side of the main cell used for ambient light metering. The required flash output is then communicated to the flash unit. There are some clever electronics at work to allow this whole operation to be done very quickly while draining the minimum of power from the flash unit's batteries. This all happens almost instantaneously as the shutter release is pressed and the exposure made.

Leica's own compact SF24D flash unit and some of the Metz 3002 system flash units with an appropriate SCA 3502 connector provide TTL metering via the pre-flash (M-TTL/GNC -Guide Number Control) system described above. This takes proper account of the lens aperture setting and any filters fitted. These dedicated units also read the camera ISO setting. Some of the larger units have a power-zoom feature that adjusts the flash reflector for the focal length of the lens fitted to the camera. If the lens is 6-bit coded and suitably enabled in the menu, the reflector is automatically adjusted. If a suitably dedicated flash is switched to A instead of TTL/GNC, the camera will communicate the ISO speed to it, but the aperture in use needs to be set manually on the flash unit as well as any filter factor. Metz, which produces the SF24D for Leica, has other larger flash units in its range such as the 54MZ4i and the 76MZ5, which are suitable for TTL/GNC with the M8 when used with the correct adapter (M4 or M5 for the 54MZ4i and M5 for the SF76). The M4 adapter is also suitable for the earlier 54MZ3 model.

...terior. The natural light was very weak and there were heavy shadows. The Metz 54 MZ was used to bounce flash ...om the ceiling and wall.

Flash units that do not have the GNC/TTL facility for preflash TTL metering can be used in the flash unit's A or Manual mode. In some cases, the camera may communicate the ISO speed to the flash unit (but not the set lens stop). With many flash units, the display panel on the rear will easily enable you to check whether or not this is the case. If a flash unit is used in A (auto) mode, do not forget to set the same lens stop on both the camera and the flash unit.

Auto Slow Sync

This feature, which is found in the main menu, provides several convenient options to facilitate settings for normal or fill-in flash. There are five settings: [Lens dependent], [Off (1/250s)], [Down to 1/30], [Down to 1/8], and [Down to 32 sec].

[Off (1/250s)] means that if the camera is set to Auto, all flash exposures will be taken with the shutter set at the maximum sync speed. Whether it is executed via the camera's TTL/GNC or the flash unit's own Auto system, this setting will work to ensure that only the main subject matter is correctly exposed. Very often, this means that the background where the flash does not reach will be dark.

Sometimes this is an advantage, but you may want to have some detail in the background areas. The other options in the menu permit this by allowing the camera, when set to Auto, to expose for the ambient light as well as the flash. They allow you to set lower shutter speeds than the 1/250 second (1/180 second on the M8.2) high-speed sync option. Without some control, this could result in blurring of the background detail due to camera shake, so the feature allows limits to be set—these are the [down to 1/30], [down to 1/8], and [Down to 32 sec] settings. This last setting effectively sets no limit. In low light conditions, this could easily

result in a blurry background unless the camera is firmly supported on a tripod or other rigid support. The actual shutter speed set by the camera's Auto (aperture priority) mode is shown in the viewfinder and some control can be exercised by varying the lens stop. When operating in this fill flash mode, the camera reduces the amount of flash so that it does not overpower the ambient light and look artificial. The trick with fill flash is for it to blend with the existing light so well that it is not noticed.

Where fill flash is being used with the camera's Manual mode, the initial ambient light exposure is calculated as in normal shooting by using the light balance diodes in the viewfinder. Provided that the shutter speed set is 1/250 (1/180 on M8.2) second or longer and [Off (1/250)] (or [Off (1/180)] on the M8.2) is not selected in the main menu, the system will operate similarly to Auto mode. With TTL flash, the preflash will calculate an appropriate level of fill flash for the ambient light. The shutter speed will always remain constant at the speed set manually so that the "down-to" settings have no effect. With a flash unit used in its Auto mode, you will need to match the stop set on the unit with the camera setting and in most cases you will need to match the ISO setting.

If a 6-bit coded lens is fitted (and enabled), selection of the [Lens dependent] option will automatically set a minimum shutter speed based on the lens focal length. This speed is based on 1/focal length in millimeters so that for a 50mm lens, it is about 1/50 second and for a 90mm lens, about 1/90 second. Generally, this is enough to prevent any serious effects of camera shake showing in the background. Note, however, that if [Lens dependent] is set and a non 6-bit coded lens is used, the shutter speed setting will revert to the [Off (1/250s)] setting.

Staircase. This shot needed the widest (16mm) setting of the Tri- Elmar, and bounce flash was used to supplement the limited amount of daylight. The flash unit was a 54MZ3 used in its Auto mode.

1st Curtain and 2nd Curtain

A further flash-related item on the main menu comes with the [Flash Sync] option. Here, you can select [1st Curtain] or [2nd Curtain]. This is also related to using a combination of flash and ambient light. By panning (following the subject as it moves past), it is possible, with a slow shutter speed, to create a blur-streaked background exposed by ambient light with a sharp image of the main subject from the very short flash exposure. If you try to do this using flash to freeze the apparent motion of the main subject as you pan, you will get a very unusual effect. With first curtain synchronization, where the flash fires immediately as the shutter starts to run, you get the strange effect of the blurred background appearing in front of the sharp main subject in the direction of its motion. With second curtain synchronization, the flash fires at the end of the cycle so that the blur appears to follow the subject, thereby giving a much more realistic impression of motion. Unless you specifically desire the second curtain effect, however, it is best to work with first curtain synchronization, as this minimizes the very short delay between the pre-flash for TTL metering and the actual exposure taking place.

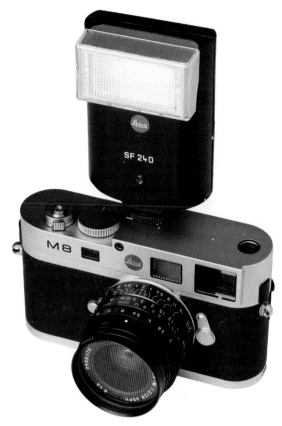

The neat little SF24D flash unit matches the compact dimensions of the M8 and can easily be fitted into an outfit case. © Brian Bower

Bounce Flash

There are many situations where the light from flash fired directly from the camera can look very harsh. Without going to the trouble of a multiple unit flash setup, it is possible to soften the light and give it some directional quality by bouncing it off of a wall or a ceiling. This does require a powerful flash unit with an adjustable head. Many flash units also have a small, switchable, secondary flash-head that remains directly aimed at the subject. When you switch this on, the limited amount of direct light that it provides ensures that the heavy shadows that can sometimes occur when flash is bounced off of a ceiling are eliminated, or at least reduced. It will also help to prevent the possibility that the nearer parts of an in-depth subject (e.g., a room) end up underexposed.

The SF24D Flash

The only flash unit that Leica supplies is the little SF24D mentioned above. This is compatible with all the features offered by the M8 models and is small and light enough to carry it around easily in the gadget bag. Although it lacks the power for any sophisticated flash techniques, it is perfectly adequate for many purposes, especially for fill flash when the ambient lighting is difficult. Against-the-light portraits outdoors are a typical example. I have also found it just powerful enough for close-up photography of insects with the 90mm Macro-Elmar. In order to diffuse the light and attempt to avoid the specular highlights that are a flash give-away with some subjects, I keep the wide-angle diffuser on the flash-head. It also helps to give a more natural effect by throwing some light onto the background.

Sam's Prom dress. This was taken outdoors in daylight and the SF24d was used to provide a touch of fill-in flash to brighten the face and shadows a little.

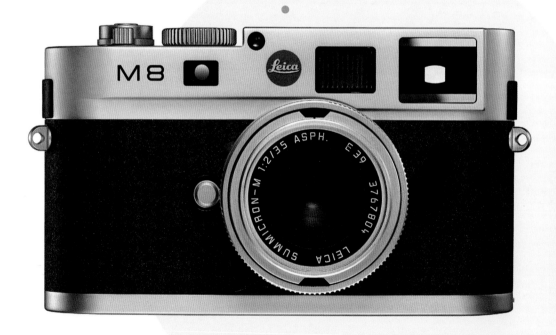

Close-up Possibilities with the Digital M

Let's be clear: A rangefinder camera is never an ideal instrument for close-up photography; an SLR is much more versatile and capable in this aspect. Nevertheless, over the years, Leica has produced some useful accessories that enable the M cameras to achieve a reasonable capability for occasional close-up requirements. At various times, in fact, the Visoflex systems were available and they converted the M (or the even earlier screw mount cameras) into single lens reflex cameras. They are slow and clumsy compared with modern SLRs but nevertheless perfectly capable of excellent images when used with skill and care.

Shells. The 50mm Summilux-M ASPH is very good in the near range. The illumination was daylight from a north-facing window together with some fill provided by a large white card reflector.

The berries were photographed using the Macro-Elmar-M together with the Macro-Adapter. Even at f/16 the depth of field is very limi

The 90mm Macro-Elmar-M

The nearest normal focusing distance of any M rangefinder lens is 28 inches (70 cm). With a 50mm, 75mm, or 90mm lens, this will be close enough for many interesting subjects but there are times a small subject or the need for a detail shot of a larger subject calls for a closer option.

The need has been met with the 90mm Macro-Elmar-M Unaided, this lens focuses down to only 2.5 feet (0.77 m), but with the Macro Adapter M, it achieves a close distance of 1.6 feet (0.5 m). This adapter adjusts the rangefinder for the closer range as well as the parallax correction for the brightline frame in the viewfinder. With the M8 models, the smallest subject area is 2.1 x 3.2 inches (54 x 81 mm) at just over 1/3 life size. This

range, depth of field is extremely limited, so the exact point has to be judged very precisely in order to make best use of the shallow area of acceptable sharp focus that is available. One great advantage of an M digital camera is that you can immediately check whether or not you've got the optimum focus and framing. With respect to framing, it should be remembered that the M8 brightline frames are optimized for 2.3 feet (0.7 m) on the M8 and 6.5 feet (2m) on the M8.2; so at closer distances, less will be included than the viewfinder shows. Due to the shallow depth of field, it will almost certainly be necessary to use the smallest stops—f/11, f/16, or f/22—at the closest distances. This means that you are likely to have to use a tripod, a flash, or a high ISO in order to avoid camera shake caused by slow shutter speeds. For static subjects, working with a tripod is obviously best, but few Leica M photographers carry tripods with them regularly, and interesting opportunities can occur at any time.

Photographing insects such as butterflies is sometimes easier with flash, especially at the kind of focusing range offered by the 90mm Macro-Elmar-M. At ISO 160 or 320 the SF24D is often adequate for exposures at f/16 or f/22, even at the closest range of the Macro-Adapter. The shutter's fastest synchronization speed of 1/250 second (M8) or 1/180 second (M8.2) and the high speed of the flash avoid any problems with camera shake. Blur caused by slight subject movement is also avoided, although subject movement can make it difficult to maintain focus. The best technique is to work hand held, pre-focus at a distance appropriate to the image required, and then just move gently backwards and forwards until the rangefinder images coincide at the optimum focus point. This takes a little practice but it is much easier than trying to constantly change the lens focus.

With a relatively static subject, it can sometimes be advantageous to slow down the shutter speed so that there is correct exposure for the ambient light of the background. The result looks more natural than with the dark background that is characteristic of a standard flash exposure.

ngs in many interesting possibilities, but without the ʋantages of ground glass viewing and focusing that ɪ have with an SLR, the techniques are demanding. st, the focusing itself requires care, plus with the relʋely small area of the 90mm lens' brightline frame the M8 (effective 120mm), accurate framing of the age is not easy either. The 1.25x or, even better, the ̤x magnifier can be a real help here. In the close-up

Some Useful Older Accessories

As well as the Visoflex reflex housing mentioned below, there are a couple of copy stands originally produced for M series film cameras that are very convenient for occasional copying requirements. Although long discontinued, they can be hunted down at specialist Leica dealers or on e-bay. They ensure that the camera is kept parallel to the subject and simplify focusing at the shorter distances. They are quick and simple to use and I find it much easier than trying to work from a tripod, adjusting the height and struggling to get everything properly lined up. They were originally produced for the full frame M film cameras, so the area that they normally cover has to be adjusted for the narrower angle of view of the M8 models. A mat can be marked up or a mask made to indicate the reduced area. The dimensions of each side will be three quarters that of the original for film. The two stands (or copying gauges as they were sometimes known) had the product codes 16526 and 16511.

The original DIN sizes are marked on the relevant extension collars into which four telescopic legs are screwed. These legs each have three locking positions also marked with the DIN size to ensure that the correct focusing distance is maintained for each collar and to delineate the area covered on the full frame area of a film M camera.

The lens, a 50mm collapsible Summicron or one of the early (not the current) collapsible 50mm f/2.8 Elmars, fits onto the collar with the lens' internal bayonet. The removable lens heads of earlier 50mm rigid Summicrons can also be fitted via adapter 16508. It is best to stop down to f/8 for flat copy or f/11 or f/16 if there is any depth in the subject.

The 16526 Stand

The 16526 (also known as the BOOWU-M) was designed to cover three fixed areas. These areas and DIN sizes, with their reduced dimensions for the M8 series, are:

The 16526 is shown assembled and disassembled. The lens is an old collapsible Summicron and the internal bayonet that fixes into the stand can be seen on the disassembled shot.

	Full frame (film)	M8 series equivalent
DIN A4	8.27 x 12.4 inches (210 x 315 mm)	6.18 x 9.25 inches (157 x 235 mm)
DIN A5	5.83 x 8.74 inches (148 x 222 mm)	4.25 x 6.38 inches (108 x 162 mm)
DIN A6	4.13 x 6.2 inches (105 x 157.5 mm)	3.07 x 4.61 inches (78 x 117 mm)

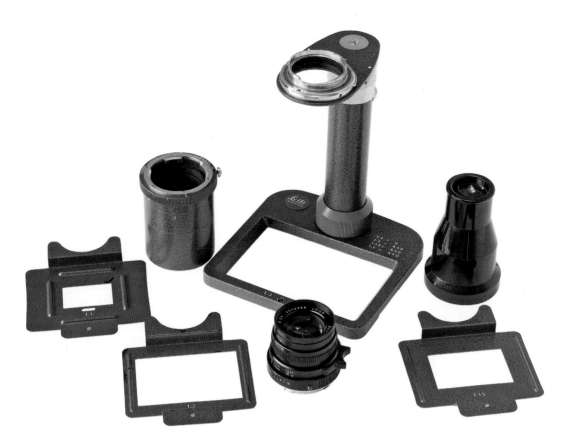

The various components of the 16511 stand are shown above and the assembled version below.

The 16511 Stand

For even closer work, the 16511 stand was designed for ratios of 1:3, 1:2, 1:1.5, and 1:1. The device consists of a stand with an adjustable column and a set of extension tubes, which are used in various combinations as is appropriate for the ratio required. Masks that are set in the base outline the field of view for each combination. These masks are relevant to the use of a full frame film M camera. The M8 models will cover a smaller area and a supplementary mask will be required, with each dimension reduced by 25%.

As shown on the opposite page, these Leica pins were photographed using the largest of the stand's frames at the 1:3 ratio. The lens used is an earlier version of the current 50mm Summicron. It is optically similar but lacks the built-in lens hood.

r focusing, the camera must be removed from the
nd and replaced with a focusing tube containing a
und glass screen. The column is first adjusted to the
proximate height using its indicative markings for
erence, and then fine focus is achieved via the
und glass. The column is then locked with a screw
the rear, and the camera is put back in place of the
using tube. Almost any 50mm M lens can be used,
t in practice, the Noctilux is not very suitable for
ch close range work. The best lens for this purpose is
bably the Summicron or an Elmar.

The Visoflex

If you are tempted to try more serious close-up photography with the M8, you should search around for one of the Visoflex attachments described in Chapter 5. The Visoflex was developed in the days before SLR cameras became popular. It effectively converts the Leica M into a reflex camera. Although it is rather slow and clumsy by modern SLR standards, it is a practical and capable accessory that enables the M owner to enjoy the fascination of really close-range subjects. Ideally, you also should have the accessory bellows unit. With various adapters, this will accept the lens heads of many older rangefinder lenses, some of which will then allow ultra-close focusing.

The 65mm Elmar (equivalent to 87mm with the M8), made especially for the Visoflex, is probably the most versatile lens. In the normal 16464 Universal Focusing Mount, it will enable you to focus to a ratio of 1:3, and if you use it on the bellows unit, you can reach 1 1/2 times life size. The later version of this lens (recognized by its black mount) is optically better than the earlier chrome-finished one.

Although it was discontinued many years ago, it is not difficult to find a Visoflex and many of the lenses at specialist dealers or on e-Bay. The bellows unit may be a little more elusive.

You will, of course, need to mask the viewfinder in order to adjust for the narrower viewing angle of the M8 models.

e Visoflex together with the bellows unit enables larger than life size images when used, as here, with the 65mm Elmar. pth of field is extremely limited even at the smallest f/22 setting on the lens. The bokeh can be very attractive.

Depth of Field

You do need to remember that in the close-up range, as you get really close to the subject, depth of field rapidly becomes quite limited. The table at Appendix A provides details. Appendix J includes details of the smallest subject area that can be achieved with each of the current lenses at its closest focusing distance.

Frankie. The depth of field at f/4 with the 75mm Summarit at its closest focussing distance used here is minimal. It is only just over 1 inch (2.5 cm).

Burnt Tree Bark. The 50mm Summilux was stopped down to f11 for this close-up.

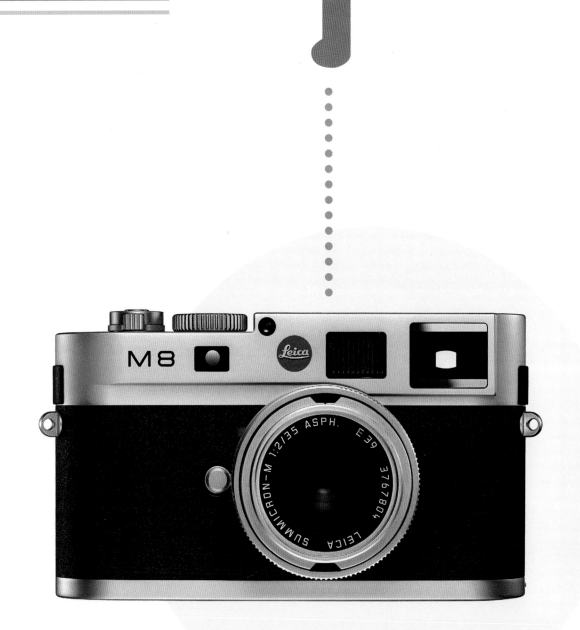

Choosing an Outfit

...e on grass. Spray from an irrigation system had frozen overnight on these grasses.

...t is always tempting to carry too much equipment with a full battery of lenses "just in case." However, this does rather defeat the purpose of owning the ...mpact Leica M, and may even result in lost opportu-...ties while debating which lens to choose or changing ...nses. In these days of greatly increased airport and ...rline security, we also have some very onerous limita-...ons on hand baggage, so planning the most space-...d weight-effective outfit often requires some thought.

...enses

...fter many years of experience with the full frame film ...cameras, the narrower angle of view that the M8 ...nsor size imposes on the Leica lenses has certainly ...rced me to rethink the most suitable outfit. The whys ...d wherefores of my experience to date are set out ...low, but of course this is a very subjective choice. ...ny outfit has to reflect personal interests and prefer-...ces, so please look upon the ideas below as a starting ...int only. In any case, particular requirements for a ...oot will often dictate specific items to take along.

Ultra-Wide Angle

Other than the 28mm and the 50mm lenses, which I consider to be the basic lenses for the M8, the choice is personal, related very much to an individual photographer's interests. My main interests are landscape and travel, so I would not want to be without my super-wide 21mm equivalent. This has to be the Tri Elmar 16-18-21 ASPH, as there is no other option within the Leica range. In terms of performance, it is a remark-able lens. At 16mm, I have the equivalent of a 21mm and, in addition, there are the equivalents to 24 and 28mm available if needed. The f/4 maximum aperture is rarely a limitation for most kinds of pictures that a super wide-angle is likely to be used for. I use my Tri-Elmar at 16mm (21mm equivalent on the M8/8.2) nearly all the time, so I usually prefer to use one of my old Leica 21mm finders rather than the bulky Universal wide-angle finder.

Taken on a flight departing from Dubai. The wide-angle Tri-Elmar was used at its widest 16mm setting in order to include the landscape together with aircraft wing for perspective.

DO NOT WALK OUTSIDE THIS AREA
DO NOT WALK OUTSIDE THIS AREA

Wide-Angle Lenses

The consensus of Leica rangefinder users has always been that the essential lens for the full frame M camera is one with a 35mm focal length. Whether this should be the f/2 Summicron or the f/1.4 Summilux has more often been the debatable point. In terms of optical quality, there is little to choose from among the current lenses, so it comes down to whether you really need that extra stop of speed or if you want to go for the more compact, lower cost Summicron; or the slightly slower still but even lower cost (and more compact) Summarit. Although I do have a Summilux, it is the Summicron that usually stays on my M7 or MP. I've always said that if I were only allowed one lens on a full frame M it would be the 35mm Summicron.

With the M8 models, the equivalent choice is between the 24mm lenses (effectively 32mm on the M8 cameras) or the 28mm lenses (effectively 37.5mm). Although all three 24mm lenses are excellent performers, the Summilux—and to a lesser extent, the Elmarit—is quite bulky. The Elmar is rather slow for such an important lens in the outfit, but the optical performance is really exceptional and it is very compact, so the intrusion into the viewfinder frame of the M8 series is minimal. The Summilux does require the separate viewfinder. I have preferred to work with the 28mm focal length and my choice is the 28mm Summicron ASPH. It is relatively compact, fast, and has outstanding performance even at full aperture. It is a really excellent lens and a favorite of many M8 series users. The 28mm Elmarit ASPH is a little gem and the most compact lens in the whole M

The 28mm Summicron is my favorite lens and was used for both of these images. The Las Vegas shot was at ISO 640. The picture of Ullswater in the English Lake District was at ISO 320 so that I could stop down for adequate depth of fiel

Normal Focal Lengths

system. In terms of overall optical performance, the 28mm Summicron is the better of these two, but in normal use you would be very hard pressed to tell the difference. On a highly subjective basis, I also think that the Summicron has the nicest image quality with very pleasant bokeh. This lens is the one that I use much more often than any other on the M8 and M8.2, and it is almost a permanent fixture on one or another of my bodies.

Besides the 35mm, the lenses that I have used most often on the full frame film Ms have been the 50, 21, and 90mm—the 50mm being the one I use the most o of the three and the 90mm the least. The 50mm and t 90mm go back to my very early days with the M2, which only had viewfinder frames for 35, 50, and 90mm lenses. The 21mm is a focal length that I fell in love with when I first attended the Leica School in Wetzlar, Germany.

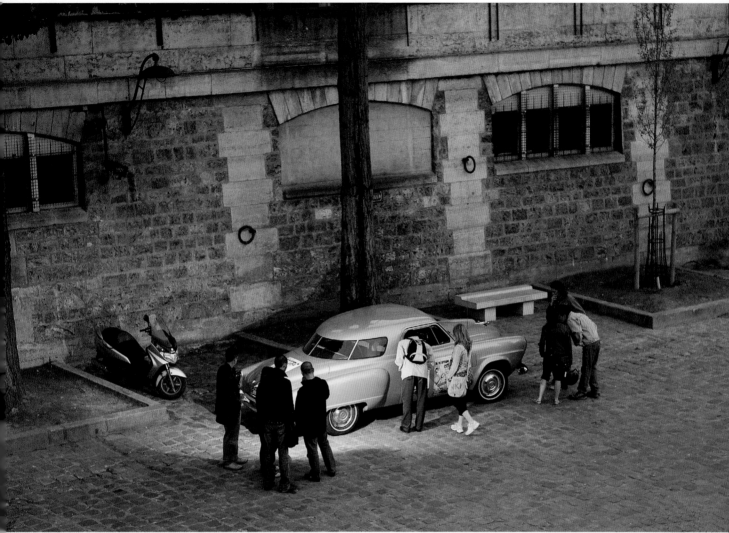

next favorite lens after the 28mm Summicron is the 50mm Summilux ASPH. The falls were shot in Milford Sound, New Zealand d the vintage car was parked on the Quai Montebello in Paris.

hink that most users of the full frame film Ms would ree that a 50mm is an essential part of their outfit, d they have a choice of four lenses: the Noctilux, mmilux, Summicron, and Summarit. To my surprise, ound that with the M8 I hardly ever use the 50mm uivalent (actual 35 mm focal length) but rather I have ntinued with the 50mm, even though it effectively comes 67mm on the M8 models. Incidentally, most mm lenses are actually between 51 and 52mm with e exact focal length usually marked on the lens bar-. This means that the effective focal length of these ses when mounted on the M8 cameras is around mm, although the EXIF data for a 50mm lens indi- tes a 67mm equivalent.

For the M8 series, I find that my 50mm Summilux ASPH, along with the 28mm Summicron, makes a great general-purpose combination with excellent low light capabilities. I consider the Summilux ASPH to be the best all-around 50mm (although the Summicron is very close), and despite the Summilux's floating element, it is still slightly better in the very near range.

The Noctilux has special appeal for its speed and creative possibilities. However, it is big and heavy and does not focus very closely. It is also extremely expensive. The Summarit offers the advantage of making for a very light, compact package. Furthermore, while it may not be as sharp at wider apertures, certainly by f/5.6 the results are virtually indistinguishable from those produced by the Summilux or the Summicron.

The Roadrunner Diner just north of Phoenix is a regular meeting place for some real characters! I sneaked this shot with the 28-35-50 Tri-

For those who wish to travel really light—walkers and climbers, for example—and for whom a lowlight capability is not so important, there is an excellent option with the fairly recently discontinued 28-35-50 Tri-Elmar ASPH, which provides near equivalents to 35, 50, and 67mm focal lengths. For many subjects, the f/4 maximum aperture is more than adequate and in terms of optical performance, by f/5.6 or f/8 it would be difficult to distinguish results produced by this lens from the classy prime lenses of similar focal lengths. In any case, as mentioned earlier, the options that you have with an M digital camera to easily increase the ISO provide a very practical safety net for these slower lenses. Also, if you can find just a little extra room in a pocket, the 90mm Macro Elmar collapses into a very small space, which adds extra versatility with little additional cost in space and weight.

Telephoto

At the longer end of the scale, the choice is between the 75mm and the 90mm focal lengths (100mm and 120mm equivalents, respectively). As much as I love my 90mm APO Summicron, it has turned out to be the 75mm APO Summicron that now goes with my M8 outfit. Previously, I used the 75mm infrequently, but because of the narrower angle of view that it provides with the M8 models, I have been seduced by it's compactness and the outstanding optical quality. There are people who consider this to be the best performing lens in the entire M range. That is really saying something!

While, perhaps it doesn't quite reach the same levels of quality as the Summicron at the wider apertures and may not be as good in the close-focusing range, the slightly slower 75mm Summarit is also a first class performer, and it costs significantly less!

Airplanes are a regular subject for my M8. This image of an Airbus 330-200 was taken with a 90mm Apo-Summicron ASPH. The shutter speed was 1/1500 second in order to avoid too much subject movement showing.

If you feel that you must have something longer than 75mm, then the 90mm APO Summicron is a great choice. With a 120mm-equivalent angle of view, you are getting very close to the classic 135mm—and it's f/2! With the reduced magnification of the M8-type viewfinder, the frame size is much the same as the 135mm frame of the M7, MP, etc. This is really a little small for accurate composition and, especially at f/2, focusing has to be done with care. A 1.25x or 1.4x magnifier helps with both framing and focusing, but the downside is that it has to be removed when using wider-angle lenses so that their viewing frames can be seen.

With the loss of only a half stop in speed, the 90mm Summarit is notably lighter and more compact than the Summicron. Its performance doesn't reach quite the same outstanding level but it would be difficult in practice to distinguish between the two lenses at f/4-f/5.6 or smaller.

Now that I am using the 75mm APO Summicron as my fast medium telephoto, unless I have a particular need for the 90mm APO Summicron ASPH, I prefer to include the very compact Macro-Elmar to cover the need for a 90mm in my outfit. Although my APO Summicron 90mm is optically superior, the close-up focusing capabilities of the Macro-Elmar together with its Macro-Adapter help to provide great, all-around versatility.

Just to close on the subject of lenses, I have been asked many times which would I choose if I were only allowed one. With the film M cameras, the answer has always been the 35mm Summicron. On the M8/8.2, the 28mm Summicron with an identical aperture and similar angle of view, is my favorite. As well as being a great lens, it plays very much to the strengths of the rangefinder M's style. It is fast, compact, and useful for a very wide range of subjects.

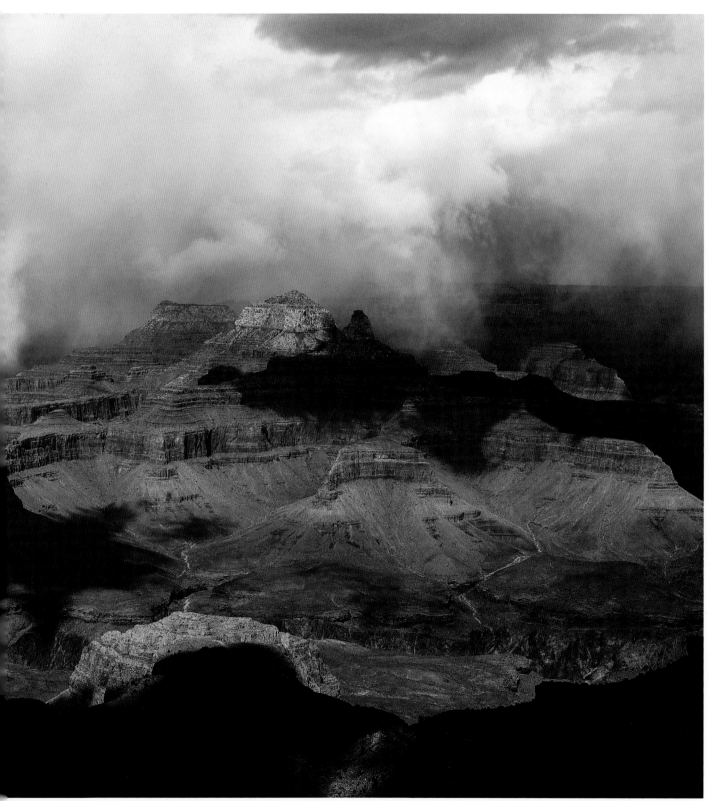

The Grand Canyon can be especially spectacular when a storm is passing through. I shot several images at different focal lengths with the 28-35-50 Tri-Elmar. This one was at 35mm.

Accessories

As well as the lenses discussed above, I like to keep the little SF24D flash in the case. The much improved flash capability of the M digital cameras compared with the earlier film models makes fill flash relatively straight-forward and, for me, this is the main attraction for using flash with the world's best available light camera.

With the film cameras, I have always kept a UVa or skylight filter on each of my lenses, mainly for protection from rain, snow, sand, and sticky fingers. Now that all of my regularly used lenses have been 6-bit coded, this filter has been replaced with a UV/IR one. If, like me, you sometimes use non-coded lenses without this filter, do not forget to change the menu item (see Chapter 2 for more information).

Generally, my lenses are without a lens cap. I've lost count of how many of these that I have lost over the years and if the lens has a filter on it, I don't think there is much need. Each lens sits in a small leather pouch within the gadget bag for a little added protection.

Other bits and pieces tucked in my case, in a sealed plastic bag to keep them as dust-free as possible, are a blower-brush and a Leica lens cleaning cloth. Very often, I also include the little table tripod with the old discontinued small ball-and-socket head and a medium sized Swiss Army knife—although the latter now has to be left out when traveling by air! Spare batteries and memory cards of course are a must. These are also kept in small plastic bags to keep them free of dust.

Hackberry General Store in Arizona is a treasure trove of Route 66 memorabilia on one of the few remaining stretches of "Mother Road". M8, 28-35-50 Tri-Elmar ASPH.

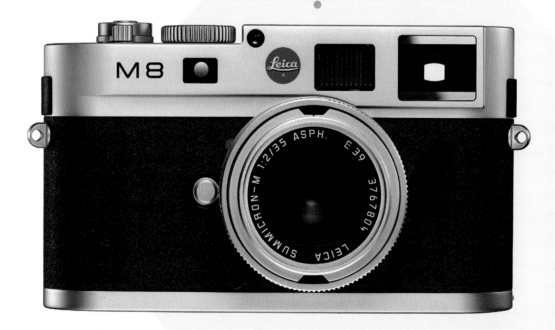

Achieving Best Image Quality

Focusing

Good photographic technique is just as important with a digital camera as with a film camera. The digital M is no different in this respect, and just like the M7 and the MP, it demands good photographic skills and knowledge to get the very best from. These skills and knowledge also need to include a reasonable understanding of what the digital controls can do to help you get the high-quality images for which the M cameras are so well known.

The basic requirements are very straightforward. Technically, what you want from a camera are sharp, accurately focused, and correctly exposed images. It sounds simple and many modern auto-everything cameras do a good job in these departments. But the M will do more than a good job; it will do an outstanding job. However, it does require input from the user. Not only does this input enable higher technical quality to be achieved but also the control that the photographer imposes provides the opportunity for a creative element that combines the aesthetic with the technical.

There is no autofocus option with the Leica M8 models, but for the range of lenses up to 90mm, the camera rangefinder provides a super-accurate method of placing the point of focus exactly where it needs to be. With wide-angle lenses in particular, there is nothing to compare with a Leica M simply because the rangefinder system is just as precise with a 16mm lens as it is with a 90mm lens.

It is important to ensure that the rangefinder image can be seen clearly. The range/viewfinder virtual distance is set at 0.5 diopter, so if you need spectacles for this distance, you will need to wear them or fit a correction lens to the viewfinder. Leica can supply screw-in correction lenses, so if your normal prescription calls for +1 diopter, you will need to order a +1.5 correction lens. Although it is not possible with spectacles to see the whole of the viewfinder comfortably, I still prefer to wear mine because I need them anyway to see the shutter speed dial and the image and menu information on the rear viewing screen clearly.

For critical focusing and a more easily framed image with the longer focal length lenses, the 1.25x or 1.4x viewfinder magnifier is helpful, especially when working at the closest distances with the Macro-Elmar, and even more so with the Macro-adapter. Depth of field is minimal at this range and the focus needs to be placed in the optimum position to maximize what little is available. The same is also true when working with fast lenses at their widest apertures. Remember, however, that with the magnifier fitted, you cannot see the brightline frames for anything other than the 75 and 90mm lenses.

Depth of Field

Look through the viewfinder of a Leica M camera and everything appears beautifully sharp; do the same with a single lens reflex camera and only a very narrow plane on which the lens is focused looks sharp, especially with longer focal length lenses. Neither view is accurate, certainly not in the case of the M and only so with the SLR if you are taking your picture at the lens' maximum aperture. With the M, a full understanding of how the focus point together with lens aperture and focal length control the practical zone of sharpness (otherwise known as depth of field) is essential. With an SLR camera, by stopping down the lens, it is possible to preview the depth of field in the viewfinder. Nevertheless, the level of magnification is relatively low and this can make it difficult to relate the apparent sharpness on the focusing screen to what will be actually achieved on an enlarged image. With an M you do not even have this option, but you can check the image on the viewing screen of the digital camera immediately after taking it, and it may be possible to reshoot the subject.

In theory, the only part of a subject that is sharp is the plane on which the lens has been focused. In practice, there is a zone in front of and behind the point of focus that the human eye still accepts as sharp. This is because its ability to distinguish detail is limited. The accepted convention is that the normal viewing distance for a print of around 8.5 x 11 inches (22 x 28 cm) is 10 inches (25 cm). At this distance, the finest point detail that the eye can resolve is generally accepted as being around 0.25 millimeters. Allowing for the degree of enlargement required, this translates to 0.030 millimeters on the sensor. This point size (or circle of confusion, as it is commonly known) is the normal basis for the calculation of depth of field tables and the depth of field scale markings on lenses. It is an arbitrary standard, and for high quality results, many photographers like to work to a more demanding basis. In my own case, I try to use an aperture setting at least one-stop smaller than the tables or depth of field scales suggest. For example, if the scale indicates that f/5.6 will provide adequate depth of field, I will use f/8.

The M8.2 with the 1.4x magnifier.

Some lenses, particularly older ones, may appear to have greater depth of field than others. In some cases uncorrected curvature of field may be the reason. For instance, the old Leica 400mm f/6.8 and 560mm f/6.8 Telyt lenses were relatively simple two-element designs that had small degrees of uncorrected curvature of field which resulted in the plane of focus curving slightly towards the camera at the edges of the image area, causing the plane of apparent focus to appear deeper. With the type of subjects for which these lenses were primarily intended—wildlife, sports, and journalism—this was hardly ever a problem, and sometimes could even be an advantage. Conversely, the extreme sharpness of modern Leica lenses in the focused plane compared with other parts of the image can emphasize the difference in sharpness between the plane of focus and other areas, and may appear to diminish the nominal depth of field.

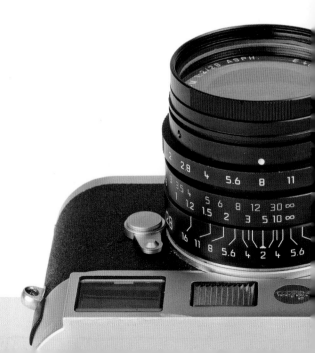

epth of field is dependent on image size, which in
urn is dependent on the distance of the subject from
he camera. Thus, a subject photographed with a 28mm
ens from the same camera position as a 90mm lens
nd with the same aperture setting will show much
reater depth of field simply because the subject is so
uch smaller. However, if part of the image from the
8mm lens is enlarged to the same size as that from the
0mm, the depth of field will be the same, although
ue to the degree of enlargement and consequent loss
f resolution, the overall quality will of course be
duced. Moving in closer with the 28mm lens so that
e size of the main subject is the same will result, in
eory, in the same depth of field. The theory works in
e close range but at greater distances, you effectively
in more depth of field with the wide angle than the
lephoto. Although the main subject is the same size,
e perspective change means that the background ele-
ents of the image are relatively smaller with the wide
gle. A quick check of the depth of field scales on the
o lenses or Leica's official depth of field tables for
ch lens (http://us.leica-cam-
a.com/photography/m_system/lenses/) will confirm
w this works. This information can help you more
ecisely control how sharp the background appears in
lation to the main subject by choosing the right lens
r the job.

28mm lens on the M8. With the focus set at 16 feet
 m) the depth of field is indicated as stretching from
5 feet (2.5 m) to infinity. For higher quality the lens
as been stopped down to f/8. © Brian Bower

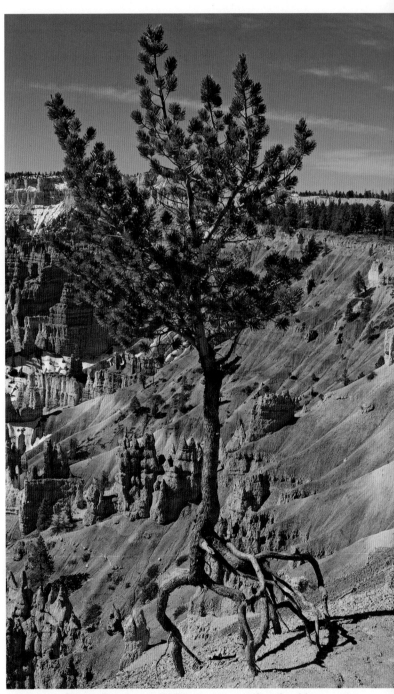

Lone Tree, Bryce Canyon. A Tri-Elmar was used at the 28mm set-
ting. An appropriate f/stop was chosen to ensure that both the tree
and the background were suitably sharp.

Hyperfocal Distance

The hyperfocal distance is the lens focus setting, which gives the maximum depth of field for a given aperture setting. This assumes that the farthest distance to be included is infinity. It sounds very complicated but it's actually quite simple—at least if the lens has a depth of field scale. Instead of focusing the lens at infinity, all you do is set the infinity mark on the focusing scale against the marking on the depth of field scale for the aperture that you are using. This maximizes the depth of field available when the subject has to include elements in the far distance as well those closer to the camera position.

This procedure has particular advantages when working with wide-angle lenses. With the M8, it is necessary to use a separate viewfinder with lenses wider than 24mm and when working quickly, in street photography for instance, it is easy to forget to set the rangefinder focus in the main viewfinder. For many subjects at normal distances, presetting these wide-angle lenses to the hyperfocal distance can save time and avoid focusing errors in these situations. As an example, the 21mm on the M with infinity set at the f/5.6 mark provides depth of field from around 4.6 feet (1.4 m) to infinity. In practice, I would set the aperture to f/8 in order to work to a one stop tighter sharpness tolerance than the standard scales allow.

Always remember that depth of field indications and the related hyperfocal distance settings rely on an arbitrary standard of perceived sharpness in the image. In effect, they rely on what is considered to be an acceptable degree of unsharpness. Only the actual plane of focus is truly sharp and delivering the lens' best performance. Truly critical requirements (Leica quality!) will always need an aperture setting one or two stops smaller than tables or lens markings may suggest.

Camera Shake

There is no doubt that the most frequent cause of unsharp images is camera shake. None of the Leica M lenses has an image stabilization feature, and given the compact dimensions and robustness that are essential parts of the M system, it is unlikely to ever become a feature.

Although I carry the little table tripod for night photography only occasionally, in studio type situations, I do use a full-size tripod. The M is, however, primarily a handheld camera. Under normal circumstances, I think that using a tripod contradicts all the discreetness and immediacy that is the hallmark of the M style.

Many people are remarkably optimistic about their ability to hold a camera steady; even the oft-quoted rule of 1/focal length as the minimum handheld speed for sharp pictures is often too slow to ensure a consistently high number of really sharp images. My rule of thumb for minimum handheld speeds, to be absolutely certain of consistently sharp results with the M is as follows:

Lens focal length	Shutter speed
16 – 28mm	1/125 second
35 – 50mm	1/250 second
75 – 135mm	1/500 second

...oeing 747. The aircraft was landing at around 160 ...ph. At this speed it moves over 200 feet in one sec- ...d. In an effort to eliminate the effect of movement ...e shutter speed used was 1/2000 second. The lens ...as a 135mm f/3.4 Apo-Telyt-M.

This is not to say that I will not use slower speeds if it is necessary. There have been many occasions when I have used speeds as slow as 1/8 or 1/15 second hand-held for an unrepeatable opportunity. But I knew that I would be unlikely to get technically perfect images, and in these cases, I took every precaution I could to steady the camera. I accepted that picture content was more important than technical perfection.

Monument Valley. Although moving relatively slowly the horses were very close to the camera. A shutter speed of 1/500 second was enough to stop any movement. Tri-Elmar-M ASPH at 35mm.

An aspect related to camera shake is subject movement. It is surprising sometimes just how much unperceived motion there is in a subject. We all know perfectly well that when shooting action pictures of a racecar or aircraft we are likely to need speeds of 1/1000 or even 1/2000 second. However, even in an apparently tranquil landscape, trees, branches, and leaves are often in constant motion because of the wind, so those relatively close to the camera are easily blurred. With many subjects, the rangefinder style is to work close with a wide-angle lens, and the closer the subject, the more apparent is any movement.

There is another good reason for keeping shutter speeds high. Remember that you can focus very accurately with the M cameras and that Leica lenses give their very best performance at wider apertures, so there is no need to stop down unnecessarily. Unless you really need the maximum depth of field, 1/500 at f/5.6 will give you a better result than 1/60 at f/16! In any case, one of the beauties of the digital M is that, if necessary, you can increase the ISO speed very easily in order to handle a difficult situation.

Paris, Sacre Coeur. By shooting DNG (RAW) images the maximum possible detail and tonal values are recorded by the camera. 28mm f/2 Summicron-M ASPH

Shoot DNG

If you are serious about your images, you will want to shoot them as RAW data. The version used by Leica with the digital M is the industry standard DNG (Digital Negative) format. Although JPEG images are a quick and easy route to prints, slide shows, or other needs, you sacrifice quality and control compared with DNG. An original DNG image retains everything that your camera captured on the sensor. It is your negative for you to process the way you want in order to maximize quality. A JPEG, on the other hand, has been subjected to significant in-camera processing and compression of the data that it contains. Also, every time you work with it and save it to a file on your computer, you lose more data and more quality.

Processing RAW images like DNG is no longer a black art. Working with Capture One, as supplied with the M models (or any of the other programs mentioned in Chapter 6) is very straightforward and well worth the effort.

In any case, the M8 cameras allow you to shoot DNG and JPEG together, so you can have the best of both worlds!

ISO Settings

The M8 models allow you a choice of five settings from ISO 160 to ISO 2500. As with film, the penalty for higher speed is a loss of quality. This manifests as lower detail resolution and noise in the image. Like grain in film, noise is best described as a lack of smoothness in large, evenly toned areas of the image (the sky, for instance) but is quite well masked in areas of considerable detail. With the M8 series, noise only becomes seriously apparent at ISO 1250 or higher, particularly at ISO 2500. However, even at these ISOs, detail resolution with Leica lenses is still very good. Although I always prefer to shoot at ISO 160 for maximum quality, ISO 640 is still very good and I don't hesitate to use faster speeds, even going up to ISO 2500 if it is necessary. The quality at the highest speeds is generally better than anything available when using film of equivalent speeds. This kind of flexibility that comes along with using a quality digital camera is a real bonus!

Antelope Canyon, Arizona. The light in the slot canyons is very weak. I had to use a high ISO (640). 28mm f/2 Summicron-M ASPH

The M8 models do have one neat trick to reduce noise in some circumstances. At shutter speeds below approximately 1/30 second, the camera takes a second black picture (with the shutter closed) and the noise in this parallel picture is subtracted from the data in the original. This takes a few seconds and for shutter speeds longer than 2 seconds, there is a warning message that it is happening. The camera should not be switched off while this is taking place.

Sunrise at 35000 feet. I wanted to capture the effect of the sun coming up. Tri-Elmar at 16mm ISO 640.

The Mosel at Bernkastel. This is an absolutely standard scene with an excellent mixture of tonal values for accurate exposure. 28mm f/2 Summicron-M ASPH

Exposure

The dynamic range of digital sensors is more limited than that of film. Although much can be done in post-processing to improve the tonal qualities of an image, there is no doubt that correct exposure is essential to realizing the exceptional quality of which the M8 cameras are capable.

In my experience, digital images require exposure accuracy at least equal to that needed with color transparency film. At best, the tolerance is plus or minus a half stop. It is particularly important not to overexpose and lose detail in the highlight areas. Working on an image later using the computer, it is often possible to lighten and retrieve detail from shadow areas, but if the highlights have been overexposed and all detail has been burned out, there is nothing there to retrieve.

For the great majority of situations, the metering system of the M8—whether in Auto or Manual mode—is very accurate. Nevertheless, unusual lighting or subject matter can fool any exposure meter, and it is important to recognize the situations where this can occur.

All exposure meters are calibrated on the basis that they are reading a combination of tones that equates to an average of 18% reflectance. If the average is lighter than this, the meter will indicate an exposure that will make them darker. If the average is darker, the meter will try to make them lighter. Thus, despite even the best efforts of the white balance, the meter may want to try to make pristine white snow into a grey mush. Alternatively, it will attempt to make a night scene look like day! Provided that you know just what area of the

A diagram of the M8/8.2 light metering pattern showing the proportion of center-weighting.

the highlights. Secondly, you can look at the histogram. This will show whether the distribution of pixels is all bunched in either the shadows (left side) or the highlights (right side). You can also magnify selected areas of the image to check the histogram for just that area.

However, be careful not to allow the histogram to rule. Although a properly exposed image will normally have a good number of pixels showing in the middle two thirds of the graph, this will not necessarily be the case in more unusual lighting situations. In the two cases mentioned earlier, there will likely be a large proportion of pixels at the highlight end (snow) or the shadow end (night). A useful guide that shows if any highlight areas are completely burned out is that if the histogram is set to show RGB with clipping, it will show a red line at the right hand edge of the graph. The burned-out areas of the image will also be shown in red. You should be aware, however, that the in-camera histogram is a guide and no more. It is based on a JPEG preview and is not fully representative of the dynamic range of a RAW (DNG) file. At both the shadow and the highlight end, clipping will start to be indicated when there may still be recoverable detail once the DNG file is processed in the computer.

icture the meter is reading, you can compensate either
y taking a reading of a more typical 18% tone and
orking with a manual mode setting or using the expo-
ire lock in Auto mode.

ith a digital camera, you do have an advantage over
sing a film camera. First, you can immediately look at
e image and check whether or not it looks right and
at there is reasonable detail in the shadows and/or

Sunset Arrival. The meter has exposed for the sky leaving the foreground as a silhouette. In this case this was the correct requirement. 28mm f/2 Summicron-M ASPH

Although they are worthwhile indications, neither the image on the screen nor the tiny histogram should be relied upon totally. If time and subject matter permit, it is always worth bracketing exposures, or taking extra shots with plus and minus half- or even full-stop variations so that these can be assessed later on the larger screen of the computer. At the processing stage of a DNG image, it is often possible that some degree of recovery of detail that might be lurking in the highlights is practicable. Similarly, there may be more detail available in the shadows than first apparent. Nevertheless, as suggested above, later correction is no substitute for getting it right when the picture is taken.

There is just one option that I ought to mention, although it is rarely relevant to the M style as it applies to a static subject and requires a tripod. This is what is known as the HDR (High Dynamic Range) method for dealing with subjects with extremes of highlights and shadows. A series of images is made at different exposures in order to maximize detail individually in the shadows, mid-tones, and the highlights. These can then be merged into one single image with the full dynamic range using Photoshop or other dedicated software.

...amsbottom Station. This was a very tricky subject with extreme contrasts. I bracketed the exposure +/- a half stop ...d then, in the computer, chose the best image to recover as much detail as possible in the highlights with further ...djustment for the heavy shadow area at the front of the locomotive.

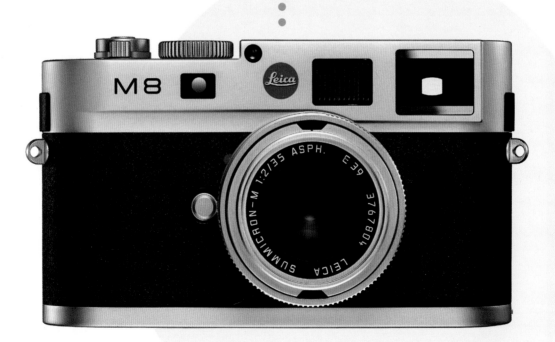

Caring for your Leica M Digital Camera and Lenses

ston Martin. This is a model of the Le Mans Aston Martin and is about 12 inches (30 cm) long. It was photographed with e 50mm Summilux-M ASPH.

The Leica M has always been one of the most robust cameras around. Despite the inevitable changes needed to accommodate the digital systems, the great majority of the mechanical and optical elements are inherited from the earlier film-based cameras. In particular, the highly evolved range/viewfinder system is almost identical with that of the M7 and of course it includes the same lenses that are used for the film cameras.

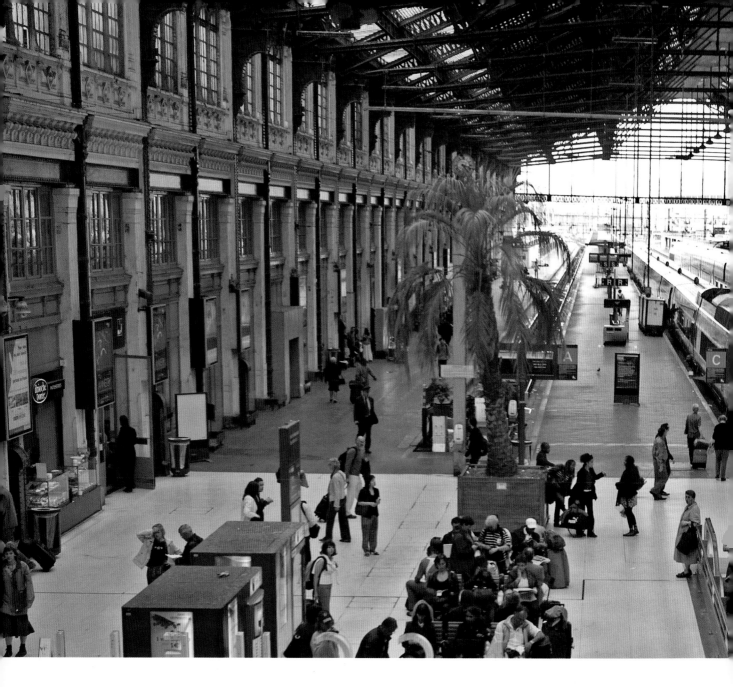

Servicing and Adjustment

Generally speaking, the best advice regarding regular maintenance of your Leica or its lenses is very simple: If it ain't broke, don't fix it. Unless you make a habit of dropping your camera down mountains or battling through war zones, it is most likely that in normal use over a reasonable period of time your camera will not need any form of regular servicing. Furthermore, any temptation to lubricate or adjust the camera or lenses yourself should be firmly resisted. You are dealing with some exceptionally manufactured and precisely assembled components that have been very carefully adjusted. Without the proper knowledge, the right tools, and appropriate skills you can only do harm. If there is a

problem, the safest thing to do is to return the camera to Leica, most definitely if the camera is still under warranty. You may not even be certain where the problem lies or that there is a problem at all. For example, the lens focusing is not absolutely spot on, it could be the lens itself, the rangefinder adjustment, or a combination of both. As with anything that is engineered and machined, there are tolerances, and it is entirely possible that a lens focuses perfectly at one distance and perhaps is very slightly less precise at another. This might simply be that the combined tolerances within the camera rangefinder system and that particular lens own focusing cam at a particular distance setting are

Paris, Gare du Nord. 28mm f/2 Summicron-M ASPH

oth to the plus side, or both to the minus side, rather
an some compensation taking place. Another lens of
e same nominal focal length could be different, due
a very slight variation in actual focal length. Even in
e worst case, however, any errors should be within
e lens' depth of field at full aperture.]

you put away your M8 and don't use it for a time, do
member to remove the battery and the memory card.
eica recommends that you should also take the camera
ut about every three months and give it a work out.
ack of use can cause lubricants to get sticky or even
ry out, so that mechanical components fail to operate

smoothly and become stiff. Fire the shutter on each of
the set speeds two or three times and operate all the
other controls such as the lens preview lever, the switch
beneath the shutter release, and the various digital con-
trols on the rear of the camera. Change lenses a few
times, and while they are on the camera, focus them
over their full range several times. Also, operate the
aperture ring from the smallest to the largest stop.

Keep it Clean

The best piece of general advice is to keep it clean! First off, the range/viewfinder windows and the eyepiece should be regularly wiped with a microfiber cloth to remove the grease smudges from fingers and eyelashes that are so easily acquired. It is quite surprising how much contrast and consequent focusing efficiency can be lost if these are not kept clean. Reluctant marks are best removed with a suitable cleaning fluid.

It is vital to keep the interior of the camera as absolutely dust free as possible. Not only is dust on the sensor the digital photographer's constant nightmare, but also tiny particles of sand or other abrasive dust are not good for mechanical and optical components either. The camera is quite well sealed, but if you have to work in adverse conditions, try to avoid having to change lenses, batteries, or SD cards. Beaches, desert regions, dusty atmospheres, and very windy and/or wet outdoor situations are typical problem areas.

With lenses, I always think that it is worth keeping a filter on at all times. Even if it is not necessary for other purposes, it is cheap protection against dirt, dust, rain, snow, scratches, and finger marks that could potentially find their way onto an expensive lens. Scientifically, it probably has some very slight adverse effect on lens performance, but if you use a good quality filter, it is all but impossible to see any difference in image quality. Ideally, with the M8/8.2, you should be using a UV/IR filter anyway. The one exception is that sometimes with very bright highlights such as streetlights in a night scene, it may be best to remove the filter to avoid ghost reflections. Filters do still need to be kept free of dust and greasy smudges. Gently remove any dust with a hurricane blower or soft brush and then carefully wipe with a microfiber cloth, using some suitable cleansing fluid if it is absolutely necessary. If you need to clean the lenses' own surfaces, the treatment is the same. From time to time, remove any dust particles from the rear elements of the lenses and keep them protected with rear lens caps when they are not on the camera.

Although it is important to keep the camera's sensor as free as possible from dust or other foreign bodies, it can be very easy to become paranoid. To get this aspect of digital photography into perspective, just remember what it was like for the film photographer who spent hours in the darkroom trying to keep his negatives free of dust in an effort to reduce the amount of time spent touching up his prints! With the digital sensor, not only is it relatively easy to get rid of spots once the image is in the computer, but once the job has been done, it doesn't have to be repeated like it did with prints from the darkroom.

Here are some facts of digital photography that you'll do best to keep in mind:

• If you use your camera regularly, you are unlikely to be able to keep the sensor free of dust for very long, no matter how hard you try.

• In areas of great detail in the image, most dust specks rarely show anyway.

• Bits of dust often don't show if you are working at a large aperture, whether it be because they are on the protective glass in front of the sensor, because they are outside the lens' depth of focus, or both.

• The cost of replacing a sensor damaged by careless cleaning is infinitely greater than the cost of a professional clean. Alternatively, the amount of time spent at the computer with the clone tool or healing brush is also of little consequence, when compared with the cost of a new sensor.

• Of course, cleaning the sensor does become necessary from time to time, but it is not as desperately vital to keep it permanently pristine as some people might suggest.

n Route 66, Arizona. 28-35-50 Tri-Elmar-M ASPH at 28mm

Leica's advice, both in the M8 instruction book and in
e FAQ section of their website, is to remove dust with
bellows type (hurricane) blower, and not by blowing
ith your mouth or using cans of compressed air. For
eper cleaning, the FAQ site says that all commercial
oducts for cleaning DSLR sensors can be used and
commends Isopropanol-based (alcohol) systems.

Nevertheless, before you start any cleaning, I recom-
end that you read the article by Dean M. Chriss at
tp://www.dmcphoto.com/Articles/SensorBrushes/ for a
od, practical overview of this subject. In common
ith what this article suggests, many digital M users
em to favor the products from Photographic Solutions
c. (www.photosol.com). Their UK distributor has a
ry good site with illustrated step-by-step instructions
owing how to clean a sensor
ttp://www.cameraclean.co.uk/acatalog/Technical_Hom
_Page.html). The recommended products for different
meras, including the digital M models, are also listed
n this site.

• Nevertheless, prevention is always better than a cure,
so my policy, whenever possible, is to avoid changing
lenses in dusty environments, to always do it as quickly
as possible, and to switch the camera off when chang-
ing lenses, because a sensor that is not electrically
charged is less likely to attract dust particles.

Batteries

Without a battery, your M8 is useless, so it pays to look after them and to ensure that they are sufficiently charged. Keep them clean, especially the contacts, and keep spare batteries in an individual dust proof container of some sort. I use a small clear plastic bag. Assuming that you do have a spare or spares, it is best to rotate them so that all of your batteries go through a regular discharge/charge cycle. The Lithium-Ion type used in the M digital models is memory-free, so they can be recharged at any level of discharge without loss of capacity. It is good practice to change a battery when the camera indicator is down to one bar. It is not good to fully discharge these batteries frequently—about once in every thirty charges is a common recommendation.

In order to keep track of them, I number my batteries. This also helps to identify any problem that might be battery-related. If for any reason you are storing a battery, Leica recommends that this is done with the battery in a partially charged condition. You can check this with the display on the top panel of the camera; one or two segments of the battery level indicator should be showing. If a battery is stored for a very long period of time, it should be charged for 15 minutes twice a year in order to avoid complete discharge. Don't forget, however, that Lithium-Ion batteries have a finite life, irrespective of how much or how little they are used. Batteries should, of course, always be removed from the camera for storage.

Finally, there are cheap third party batteries around of dubious quality. Play it safe: Stick with the official Leica batteries to avoid potential problems or voiding your warranty.

Paris, Place du Tertre, 28mm f/2 Summicron-M ASPH

appendix

CLOSE-UP DEPTH OF FIELD (A)

REPRODUCTION SCALE	MAGNIFICATION	DEPTH OF FIELD IN MM F4	DEPTH OF FIELD IN MM F5.6	DEPTH OF FIELD IN MM F8	DEPTH OF FIELD IN MM F11	DEPTH OF FIELD IN MM F16	DEPTH OF FIELD IN MM F22
1:10	0.1X	30	40	60	80	120	160
1:5	0.2X	8	10	15	20	30	40
1:4	0.25X	5.5	7.5	11	15	20	30
1:3	0.33X	3	4.5	6	9	12	18
1:2	0.5X	1.5	2	3	4	6	8
1:1.5	0.67X	1	1.4	2	2.7	4	5.5
1:1	1X	0.5	0.7	1	1.4	2	2.7
1.5:1	1.5X	0.3	0.4	0.6	0.8	1	1.6
2:1	2X	0.2	0.3	0.4	0.6	0.8	1.2
3:1	3X	0.1	0.2	0.25	0.35	0.5	0.7
4:1	4X	0.08	0.12	0.16	0.23	0.32	0.5

NOTE: FIGURES ARE ROUNDED

 (B)

Instructions for updating the LEICA M8 Firmware

1. Format an SD memory card (not an SDHC card) in your LEICA M8.

2. Turn off the camera and insert the card into an SD card reader – either integrated or connected to your computer. (A reader is required for Firmware updates).

3. Download the Firmware file from the Leica M8 site using the "UPDATES" link and unzip the file.

4. Save the unzipped file m8-2_000.upd at the top level of the card's folder structure.

Name ▾	Größe	Typ	Geändert am
DCIM		Dateiordner	29.07.2008 12:01
m8-2_000.upd	4.897 KB	UPD-Datei	03.09.2008 11:12

Illustration: Top level of card's folder structure

5. Remove the card properly from your card reader, insert the card into the camera and close the bottom cover.

6. Turn on the camera using the main switch and **wait for at least 3 seconds** before continuing with step 7.

7. Confirm the prompt that appears in the monitor as to whether you want to update the Firmware on the camera to version 2.000.

 The update process takes around 180s. You will then be prompted to restart the camera using the main switch.

8. Turn the camera off and back on again.

Note: If the battery does not have sufficient charge, you will see a corresponding warning message.

Firmware version 2.000 - The update adds these improvements to your camera:

Compatibility to memory cards in the SDHC standard up to 32GB capacity.

Note: The choice of SD and SDHC cards in the market is already very big and is constantly growing. Therefore, Leica Camera AG is not able to do comprehensive compatibility- and quality testing with all available cards in the market. We recommend "Extreme III" or "Professional" from the leading brands such as "SanDisk" or "Lexar". Using other card types, will not damage camera or card, but as especially "no name" cards do not respect the full SD or SDHC standards, Leica Camera AG cannot warranty full function with those cards.

New function "AUTO-ISO" with setting options for maximum ISO values and the slowest shutter speed (please see also instructions for LEICA M8.2 from page 121)

Note: It is <u>not</u> possible to "downdate" LEICA M8 cameras to previous firmware releases, once the version 2.000 has been installed.

 (C)

Using the LEICA M8, firmware version 1.102 with the LEICA TRI-ELMAR-M 16-18-21mm f/4 ASPH. and a LEICA UV/IR filter

About the lens

The LEICA M8 has an increased sensitivity to infrared light. This manifests itself in a slightly purple rendering of dark or black surfaces (particularly black textiles). Using the LEICA UV/IR filter in front of the lens effectively prevents this from occurring.

When using wide-angle lenses from 16 to 35mm with the LEICA UV/IR filter, a focal length specific correction of the color cast towards the edge of the image is required. With 6-bit coded lenses, this is done automatically in the camera as the lens type is transferred to the LEICA M8 as part of the coding. However, in the case of the LEICA TRI-ELMAR-M 16-18-21mm f/4 ASPH., the lens type transferred does not always correspond to the focal length actually set on the lens. Additional information is therefore required. When the LEICA M8 is being operated with the Firmware version 1.10 (or higher), the focal length specific correction is possible for this lens too. To do this, the Firmware version includes an extended menu:

1. Under the menu item „Lens detection", select the sub-point "On + UV/IR" by pressing the SET button. A new monitor screen appears with the title „Lens detection Tri-Elmar + UV/IR".

 Note:
 Provided "On + UV/IR" has previously been set, this monitor screen appears automatically as soon as the camera is turned on and/or the LEICA TRI-ELMAR 16-18-21mm f/4 ASPH is attached, regardless of whether or not the monitor was previously active.

2. In the box with a red border, the three focal lengths 16, 18, and 21mm can be selected using the direction buttons and/or the central adjusting dial and confirmed as normal with the SET button.

 Notes:

 - The setting in the menu must be made <u>every time</u> the focal length on the lens is changed.

 - When the lens is attached, the middle focal length of 18mm is always preselected.

 - This manual adjustment of the focal length in the menu is only necessary with the LEICA TRI-ELMAR-M 16-18-21mm f/4 ASPH. The LEICA TRI-ELMAR-M 28-35-50mm f/4 ASPH. features the necessary mechanical transfer of the set focal length to the camera to display the appropriate bright-line frame in the viewfinder. The camera electronics detect the setting and use it to perform focal length specific correction.

About the filter

- The LEICA UV/IR filter combined with lenses from 16-28mm focal length should not be used for shots under fluorescent light (fluorescent tubes). As fluorescent tubes emit light with a very uneven spectrum, this could result in incorrect color correction.

- As with all optical filters placed in front of the shooting lens and strong light sources in the picture, using the LEICA UV/IR filter can result in a reflection visible in the image, i.e. a duplicate reproduction of the light source.

- Light incident from behind –entering through the cut-outs in the filter mount for the LEICA TRI-ELMAR-M 16-18-21mm f/4 ASPH. – can lead to reflections in the image when using the LEICA UV/IR filter. When using the filter, you should therefore close the notches using the plastic ring supplied with the filter mount. In case you already have the filter holder, but not the plastic ring, you can order the latter from your Leica distributor.

 (D)

M lens coding
List of update capable M lenses for digital use

List of present lenses that can be updated:

Name	Color	Order No.	Delivered from
Elmarit-M 21mm f/2.8 ASPH.	Black	11135	1997
Elmarit-M 24mm f/2.8 ASPH.	Black	11878	1996
Summicron-M 28mm f/2 ASPH.	Black	11604	2000
Tri-Elmar-M 1:4/28-35-50mm f/4 ASPH.	Black	11625	2000
Summilux-M 35mm f/1.4 ASPH.	Black	11874	1994
Summicron-M 35mm f/2 ASPH.	Black	11879	1996
Summicron-M 35mm f/2 ASPH.	Silver	11882	1996
Noctilux-M 50mm f/1.0	Black	11822	1994
Summilux-M 50mm f/1.4 ASPH.	Black	11891	2004
Summilux-M 50mm f/1.4 ASPH.	Silver	11892	2006
Summicron-M 50mm f/2	Black	11826	1994
Summicron-M 50mm f/2	Silver	11816	1994
Elmar-M 50mm f/2.8	Black	11831	1995
Elmar-M 50mm f/2.8	Silver	11823	1994
Summilux-M 75mm f/1.4	Black	11810	1998
Apo-Summicron-M 75mm f/2 ASPH.	Black	11637	2005
Apo-Summicron-M 90mm f/2 ASPH.	Black	11884	1998
Elmarit-M 90mm f/2.8	Black	11807	1990
Macro-Elmar-M 90mm f/4	Black	11633	2002
Macro-Elmar-M 90mm f/4	Silver	11634	2002
Macro-Adapter M	Black	14409	2002

The only lens in the current range that will not be given a 6-bit coding is the LEICA APO-TELYT-M 135 mm f/3.4. It is not codable later, either, as its extension factor of 1.33 makes it unsuitable for use on the digital M camera.

Discontinued lenses that can be updated:

Besides those presently available, even lenses that were discontinued quite a while ago can be updated (see list below). Since Leica Camera AG regards system compatibility as a vital virtue, many lenses introduced as long ago as 1963 can be updated.

List of discontinued lenses that can be updated:

Name	Color	Order No.	Delivered from-until
Elmarit-M 21mm f/2.8	Black	11134	1980-1997
Elmarit-M 21mm f/2.8 ASPH.	Silver	11897	1997-2004
Elmarit-M 24mm f/2.8 ASPH.	Silver	11898	1996-2005
Elmarit-M 28mm f/2.8	Black	11804	1979-1992
Elmarit-M 28mm f/2.8	Black	11809	1992-2005
Tri-Elmar-M 28-35-50mm f/4 ASPH.	Black	11890	1998-2000
Tri-Elmar-M 28-35-50mm f/4 ASPH.	Silver	11894	1999-2000
Summilux-M 35mm f/1.4 ASPH.	Silver	11883	1994-2004
Summicron-M 35mm f/2	Black	11310	1979-1996
Summicron-M 35mm f/2	Silver	11311	1993-1996
Noctilux-M 50mm f/1.0	Black	11821	1975-1994
Summilux-M 50mm f/1.4	Black	11868	1992-2004
Summilux-M 50mm f/1.4	Silver	11856	1992-2004
Summicron-M 50mm f/2	Black	11817	1969-1979
Summicron-M 50mm f/2	Black	11819	1979-1994
Summicron-M 50mm f/2	Silver	11825	1992-1994
Summilux-M 75mm f/1.4	Black	11814	1980-1982
Summilux-M 75mm f/1.4	Black	11815	1982-1998
Summicron-M 90mm f/2	Black	11136	1980-1989
Summicron-M 90mm f/2	Silver	11137	1993-1989
Apo-Summicron-M 90mm f/2 ASPH.	Silver	11885	2002-2004
Tele-Elmarit-M 90mm f/2.8	Black	11800	1973-1989
Elmarit-M 90mm f/2.8	Silver	11808	1997-2004
Elmarit-M 135mm f/2.8	Black	11829	1963-1997

Please ask either your authorized Leica dealer or Customer Service in Solms to perform the update. The latter will be happy to inform you on this subject. Customer Service is available under the phone number +49 (0)6442 208-189.

LEICA M8 / LEICA M8.2 (E)

Technical Data

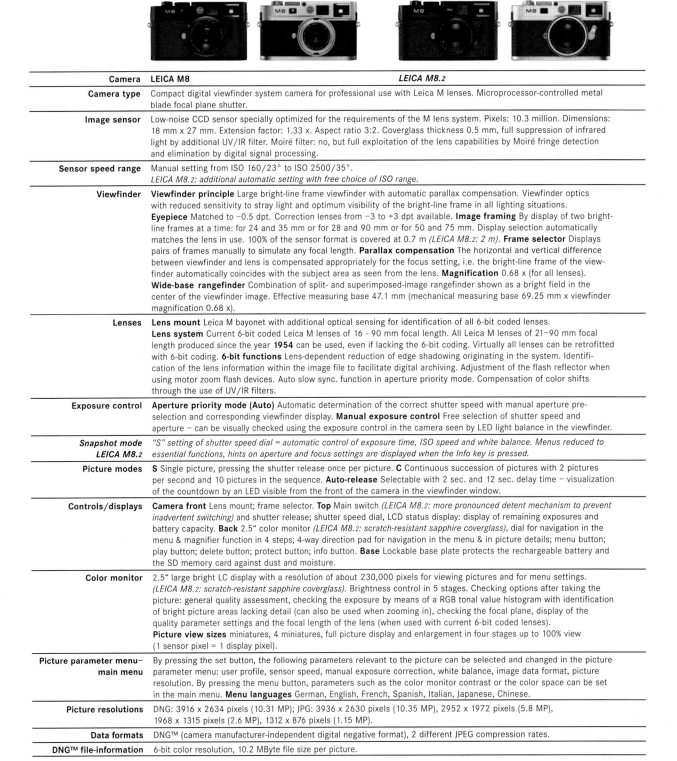

Camera	LEICA M8	LEICA M8.2
Camera type	Compact digital viewfinder system camera for professional use with Leica M lenses. Microprocessor-controlled metal blade focal plane shutter.	
Image sensor	Low-noise CCD sensor specially optimized for the requirements of the M lens system. Pixels: 10.3 million. Dimensions: 18 mm x 27 mm. Extension factor: 1.33 x. Aspect ratio 3:2. Coverglass thickness 0.5 mm, full suppression of infrared light by additional UV/IR filter. Moiré filter: no, but full exploitation of the lens capabilities by Moiré fringe detection and elimination by digital signal processing.	
Sensor speed range	Manual setting from ISO 160/23° to ISO 2500/35°. _LEICA M8.2: additional automatic setting with free choice of ISO range._	
Viewfinder	**Viewfinder principle** Large bright-line frame viewfinder with automatic parallax compensation. Viewfinder optics with reduced sensitivity to stray light and optimum visibility of the bright-line frame in all lighting situations. **Eyepiece** Matched to –0.5 dpt. Correction lenses from –3 to +3 dpt available. **Image framing** By display of two bright-line frames at a time: for 24 and 35 mm or for 28 and 90 mm or for 50 and 75 mm. Display selection automatically matches the lens in use. 100% of the sensor format is covered at 0.7 m _(LEICA M8.2: 2 m)_. **Frame selector** Displays pairs of frames manually to simulate any focal length. **Parallax compensation** The horizontal and vertical difference between viewfinder and lens is compensated appropriately for the focus setting, i.e. the bright-line frame of the viewfinder automatically coincides with the subject area as seen from the lens. **Magnification** 0.68 x (for all lenses). **Wide-base rangefinder** Combination of split- and superimposed-image rangefinder shown as a bright field in the center of the viewfinder image. Effective measuring base 47.1 mm (mechanical measuring base 69.25 mm x viewfinder magnification 0.68 x).	
Lenses	**Lens mount** Leica M bayonet with additional optical sensing for identification of all 6-bit coded lenses. **Lens system** Current 6-bit coded Leica M lenses of 16 - 90 mm focal length. All Leica M lenses of 21–90 mm focal length produced since the year **1954** can be used, even if lacking the 6-bit coding. Virtually all lenses can be retrofitted with 6-bit coding. **6-bit functions** Lens-dependent reduction of edge shadowing originating in the system. Identification of the lens information within the image file to facilitate digital archiving. Adjustment of the flash reflector when using motor zoom flash devices. Auto slow sync. function in aperture priority mode. Compensation of color shifts through the use of UV/IR filters.	
Exposure control	**Aperture priority mode (Auto)** Automatic determination of the correct shutter speed with manual aperture pre-selection and corresponding viewfinder display. **Manual exposure control** Free selection of shutter speed and aperture – can be visually checked using the exposure control in the camera seen by LED light balance in the viewfinder.	
Snapshot mode LEICA M8.2	_"S" setting of shutter speed dial = automatic control of exposure time, ISO speed and white balance. Menus reduced to essential functions, hints on aperture and focus settings are displayed when the Info key is pressed._	
Picture modes	**S** Single picture, pressing the shutter release once per picture. **C** Continuous succession of pictures with 2 pictures per second and 10 pictures in the sequence. **Auto-release** Selectable with 2 sec. and 12 sec. delay time – visualization of the countdown by an LED visible from the front of the camera in the viewfinder window.	
Controls/displays	**Camera front** Lens mount; frame selector. **Top** Main switch _(LEICA M8.2: more pronounced detent mechanism to prevent inadvertent switching)_ and shutter release; shutter speed dial, LCD status display: display of remaining exposures and battery capacity. **Back** 2.5" color monitor _(LEICA M8.2: scratch-resistant sapphire coverglass)_, dial for navigation in the menu & magnifier function in 4 steps; 4-way direction pad for navigation in the menu & in picture details; menu button; play button; delete button; protect button; info button. **Base** Lockable base plate protects the rechargeable battery and the SD memory card against dust and moisture.	
Color monitor	2.5" large bright LC display with a resolution of about 230,000 pixels for viewing pictures and for menu settings. _(LEICA M8.2: scratch-resistant sapphire coverglass)_. Brightness control in 5 stages. Checking options after taking the picture: general quality assessment, checking the exposure by means of a RGB tonal value histogram with identification of bright picture areas lacking detail (can also be used when zooming in), checking the focal plane, display of the quality parameter settings and the focal length of the lens (when used with current 6-bit coded lenses). **Picture view sizes** miniatures, 4 miniatures, full picture display and enlargement in four stages up to 100% view (1 sensor pixel = 1 display pixel).	
Picture parameter menu– main menu	By pressing the set button, the following parameters relevant to the picture can be selected and changed in the picture parameter menu: user profile, sensor speed, manual exposure correction, white balance, image data format, picture resolution. By pressing the menu button, parameters such as the color monitor contrast or the color space can be set in the main menu. **Menu languages** German, English, French, Spanish, Italian, Japanese, Chinese.	
Picture resolutions	DNG 3916 x 2634 pixels (10.31 MP); JPG: 3936 x 2630 pixels (10.35 MP), 2952 x 1972 pixels (5.8 MP), 1968 x 1315 pixels (2.6 MP), 1312 x 876 pixels (1.15 MP).	
Data formats	DNG™ (camera manufacturer-independent digital negative format), 2 different JPEG compression rates.	
DNG™ file-information	6-bit color resolution, 10.2 MByte file size per picture.	

Memory medium	SD and SDHC cards up to 32 GByte. Complete list of LEICA M8- and M8.2-compatible SD memory cards: www.leica-camera.de/photography/m_system/m8
White balance	Automatic, 6 preset values, manual white balance, color temperature input from 2000K to 13,100K.
Color spaces	Adobe®RGB, sRGB, ECI RGB.
Viewfinder display	(at the bottom edge of the viewfinder) LED symbol for flash status, four-digit seven-segment LED display with dots above and below (display brightness is always adjusted for ambient brightness) for: display of the automatically calculated shutter speed in aperture priority mode, indication of the use of saved metering values, warning of exposure corrections, warning of when the metering range is overshot or undershot in aperture priority mode and countdown display of shutter times longer than 2 sec., memory capacity warning when the SD card is full. LED light balance with two triangular and one central circular LED for manual exposure setting. Display of: underexposure by at least one aperture stop; underexposure by 1/2 aperture stop; correct exposure; overexposure by 1/2 aperture stop; overexposure by at least one aperture stop. Triangular LEDs give the direction of rotation of the aperture setting ring and shutter speed setting dial to adjust the exposure. The LED flashes as a warning that the metering range is overshot or undershot. *(LEICA M8.2: In "S" mode: red dot to indicate correct exposure, left arrow to warn against camera shake, right arrow to warn against overexposure).*
Exposure metering	Heavily center-weighted TTL exposure metering with pre-set working aperture. **Metering principle** Light reflected from a white strip in the centre of the metal blade focal plane shutter. **Metering range** EV0 to EV20 at 20°C room temperature, aperture 1.0 and ISO 160/23°. **Metering cell** Silicon photodiode with collection lens positioned at the center of the lower edge of the camera base.
Flash exposure metering/ control using M-TTL flash technology	**Principle** Using an extremely short calibration pre-flash fired immediately before the exposure, the exact power requirement for the main flash is determined. **Connection** M-TTL guide number control with calibration pre-flash via accessory shoe SCA 3502 (version M4) or with Leica flash SF24D. **Flash synchronization time** 1/250 sec. *(LEICA M8.2: 1/180 sec.)* synchronization permits creative open aperture photography even in bright ambient light. **Manual** Flash synchronization times from B (bulb) down to 1/250 sec. *(LEICA M8.2: 1/180 sec.)* **Aperture priority mode** Auto Slow Sync: automatic extension of the longest flash time, using the rule of thumb 1/focal length in seconds. (only with 6-bit coded lenses). Choice of long flash synchronization times up to e.g. 1/8 sec. for balanced flash when taking available light pictures in aperture priority mode. **Synchronization flash firing time** Firing optionally at the 1st or 2nd shutter point (with appropriate flash device such as the LEICA SF24D or when using the SCA-3502 adapter).**Flash exposure correction** ±3 1/3 EV in 1/3 EV-Stufen stages adjustable at the SCA-3501/3502 adapter. Settable at the LEICA SF 24D ± 3EV in 1/3 EV stages, or from 0 to −3 EV in 1EV stages when using computer control.
Shutter and shutter release	**Shutter** Microprocessor-controlled metal blade focal plane shutter with vertical action. *(LEICA M8.2: optimized to reduce noise and vibration).* **Shutter times** In aperture priority mode (**A**) steplessly adjustable from 32 s down to 1/8000 s *(LEICA M8.2: 1/4000 s).* With manual setting from 4 s down to 1/8000 s *(LEICA M8.2: 1/4000 s)* in half steps. **B** for long exposures of any length. **Activation** Shutter activation optimized for minimum noise. Electric motor drive with friction wheel in the first speed build-up stage and a cam disk for homogenous torque throughout the activation process. *(LEICA M8.2: time-delayed cocking after shutter button is released, selectable in menu).* **Release** Three-stage activation governed by how far the release is depressed: 1. Switch the camera electronics on & activate the exposure metering – 2. Save metered value (in aperture priority mode) – 3. Release (includes a standard thread for cable release). **Power supply** Lithium ion rechargeable battery with a nominal voltage of 3.7 V and a capacity of 1900 mAh. **Interface** 5-pin standard mini-USB socket on the left side of the body, for quick USB 2.0 data transfer to a computer.
Camera body	**Material** Enclosed all-metal body of highly stable magnesium alloy for professional use over many years. Black synthetic leather coating. Top cap and base plate are milled from solid brass and are silver or black chromium plated *(LEICA M8.2: black paint finished).* **Tripod thread** DIN 4503 – A1/4 (1/4") in the centre of the bottom cover.
Dimensions (W x H x D)	approx. 139 x 80 x 37 mm
Weight without battery	approx. 545 g
Scope of supply	M8 camera (10702 silver or 10701 black), *M8.2 camera (10712 silver or 10711 black),* anti-slip carrying strap (14 312), camera cap for M bayonet (14 195), rechargeable lithium ion battery (14 464), battery charger incl. car socket adaptor and 3 mains plug adapters (Euro, UK, USA) (14 463), *(LEICA M8.2: compact charger with 80% charge display car socket and EURO/USA mains leads),* USB connection cable, user manual, software DVD Capture One 4, warranty card.

EARLIER LEICA LENSES (F)

Lens	Note	Focal Length in mm Maximim Aperture	Angle of View Degrees (k)	Elements / Groups	Smallest Aperture	Focusing Range	Filter Size	Weight gm	Finish	Available From-To	Code
HOLOGON		15 f8	110	3/3	f8	inf-0.2m	special	120	black	1973-1976	11135
SUPER ANGULON		21 f4	92	9/4	f22	inf-0.4m	E39	250	chrome	1958-1963	11102
SUPER ANGULON	(f)	21 f3.4	92	8/4	f22	inf-0.4m	E48/S7	300	black	1963-1980	11103
ELMARIT-M		21 f2.8	92	8/6	f16	inf-0.7m	E60	290	black	1980-1997	11134
ELMARIT		28 f2.8	76	9/6	f22	inf-0.7m	E48/S7	225	black	1965-1969	11801
ELMARIT	(a)	28 f2.8	76	8/6	f22	inf-0.7m	E48/S7	225	black	1969-1980	11801
ELMARIT		28 f2.8	76	8/6	f22	inf-0.7m	E49	240	black	1980-1993	11804
ELMARIT-M		28 f2.8	76	8/7	f22	inf-0.7m	E46	260	black	1992-2006	11809
SUMMARON (M3 type)		35 f3.5	64	6/4	f22	inf-1m	E39	220	chrome	1956-1958	11107
SUMMARON		35 f3.5	64	6/4	f22	inf-1m	E39	135	chrome	1958-1959	11305
SUMMARON (M3 type)		35 f2.8	64	6/4	f22	inf-0.65m	E39	220	chrome	1958-1973	11106
SUMMARON		35 f2.8	64	6/4	f22	inf-0.7m	E39	135	chrome	1958-1973	11306
SUMMICRON (M3 type)		35 f2	64	8/6	f16	inf-0.65m	E39	250	black	1958-1973	11104
SUMMICRON (M3 type)		35 f2	64	8/6	f16	inf-0.65m	E39	250	chrome	1958-1973	11108
SUMMICRON		35 f2	64	8/6	f16	inf-0.7m	E39	150	black	1958-1969	11307
SUMMICRON		35 f2	64	8/6	f16	inf-0.7m	E39	150	chrome	1958-1969	11308
SUMMICRON		35 f2	64	6/4	f16	inf-0.7m	S7	170	chrome	1969-1973	11309
SUMMICRON	(b)	35 f2	64	6/4	f16	inf-0.7m	E39/S7	170	black	1973-1980	11309
SUMMICRON-M		35 f2	64	7/5	f16	inf-0.7m	E39	160	black	1980-1997	11310
SUMMICRON-M		35 f2	64	7/5	f16	inf-0.7m	E39	250	chrome	1992-1997	11311
SUMMILUX		35 f1.4	64	7/5	f16	inf-1m	S7	195	chrome	1961-1994	11870
SUMMILUX-M titanium		35 f1.4	64	7/5	f16	inf-1m	S7	195	titanium	1992-1994	11860
SUMMILUX (M3 type)		35 f1.4	64	7/5	f16	inf-0.65m	S7	325	black	1960-1974	11871
SUMMILUX-M ASPHERIC		35 f1.4	64	9/5	f16	inf-0.7m	E46	300	black	1990-1994	11873
ELMAR	(c)	50 f3.5	45	4/3	f22	inf-1m	E39	210	chrome	1954-1962	11110
ELMAR	(c)	50 f2.8	45	4/3	f22	inf-1m	E39	220	chrome	1958-1966	11112
ELMAR (M6J special)	(c)	50 f2.8	45	4/3	f16	inf-0.7m	E39	200	chrome	1994	12549
ELMAR-M	(c)	50 f2.8	45	4/3	f16	inf-0.7m	E39	170	black	1994-2007	11831
ELMAR-M	(c)	50 f2.8	45	4/3	f16	inf-0.7m	E39	245	chrome	1994-2007	11823
SUMMICRON	(c)	50 f2	45	7/6	f16	inf-1m	E39	220	chrome	1954-1957	11116
SUMMICRON		50 f2	45	7/6	f16	inf-1m	E39	285	chrome	1957-1969	11818
SUMMICRON		50 f2	45	7/6	f16	inf-1m	E39	285	black	1957-1969	11117

ens		Focal Length in mm Maximim Aperture	Angle of View Degrees (k)			Focusing Range	Filter Size		Finish	Available From-To	Code
UMMICRON (close-focus)		50 f2	45	7/6	f16	inf-1m	E39	400	chrome	1956-1968	11918
UMMICRON		50 f2	45	6/5	f16	inf-0.7m	E39	260	black	1969-1979	11817
UMMICRON-M		50 f2	45	6/4	f16	inf-0.7m	E39	225	black	1980-1994	11819
UMMICRON-M		50 f2	45	6/4	f16	inf-0.7m	E39	295	chrome	1993-1994	11825
UMMARIT		50 f1.5	45	7/5	f16	inf-1m	E41	320	chrome	1954-1960	11120
UMMILUX	(d)	50 f1.4	45	7/5	f16	inf-1m	E43	325	black	1959-1995	11114
UMMILUX		50 f1.4	45	7/5	f16	inf-0.7m	E43	325	black	1995-2004	11868
UMMILUX		50 f1.4	45	7/5	f16	inf-0.7m	E43	325	chrome	1996-2004	11856
UMMILUX		50 f1.4	45	7/5	f16	inf-0.7m	E43	325	titanium	1995-2004	11869
OCTILUX		50 f1.2	45	7/6	f16	inf-1m	S8	515	black	1966-1975	11820
OCTILUX		50 f1.0	45	7/6	f16	inf-1m	E60	630	black	1976-1994	11821
OCTILUX-M		50 f1.0	45	7/6	f16	inf-1m	E60	630	black	1994-2007	11822
UMMILUX-M		75 f1.4	31	7/5	f16	inf-0.75m	E60	560	black	1980-2007	11810
LMAR		90 f4	27	4/3	f32	inf-1m	E39	240	chrome	1954-1963	11130
LMAR	(c)	90 f4	27	4/3	f32	inf-1m	E39	300	chrome	1954-1968	11131
LMAR		90 f4	27	3/3	f32	inf-1m	E39	305	chrome	1964-1968	11830
ACRO-ELMAR-M		90 f4	27	4/4	f22	inf-0.76m	E39	240	black	2004-2007	11633
ACRO-ELMAR-M		90 f4	27	4/4	f22	inf-0.76m	E39	320	chrome	2004-2007	11634
LMARIT-M		90 f2.8	27	4/4	f22	inf-1m	E46	410	black	1990-2007	11807
LMARIT-M		90 f2.8	27	4/4	f22	inf-1m	E46	410	chrome	1997-2007	11808
LMARIT-M		90 f2.8	27	4/4	f22	inf-1m	E46	560	titanium	1997	11899
LMARIT	(e)	90 f2.8	27	5/3	f22	inf-1m	E39	560	chrome	1959-1974	11129
ELE-ELMARIT	(f)	90 f2.8	27	5/5	f16	inf-1m	E39	355	black	1964-1974	11800
ELE-ELMARIT		90 f2.8	27	4/4	f16	inf-1m	E39	225	black	1974-1990	11800
JMMICRON	(g)	90 f2	27	6/5	f22	inf-1m	E48	660	black	1957-1979	11123
JMMICRON-M		90 f2	27	5/4	f22	inf-1m	E55	475	black	1979-1998	11136
JMMICRON-M ver		90 f2	27	5/4	f22	inf-1m	E55	690	chrome	1993-1998	11137
EKTOR		135 f4.5	18	4/3	f32	inf-1.5m	E39	560	chrome	1954-1960	11135
LMAR		135 f4.0	18	4/4	f22	inf-1.5m	E39	550	chrome	1960-1965	11850
ELE-ELMAR		135 f4.0	18	5/3	f22	inf-1.5m	E39	510	black	1965-1994	11851
ELE-ELMAR		135 f4.0	18	5/3	f22	inf-1.5m	E46	550	black	1994-1998	11861
LMARIT	(h)	135 f2.8	18	5/4	f32	inf-1.5m	S7	730	black	1963-1998	11829
RI-ELMAR-M SPH 28-35-50		28-35-50f4	76/64/45	8/6	f22	inf-1m	E55	340	black	2008-2000	11890
RI-ELMAR-M SPH 28-35-50		28-35-50f4	76/64/45	8/6	f22	inf-1m	E55	460	chrome	2008-2000	11894
RI-ELMAR-M SPH 28-35-50		28-35-50f4	76/64/45	8/6	f22	inf-1m	E49	340	black	2000-2007	11625

New design from serial 2314921.
New design from serial 2461001.
Collapsible mount.
New optical design from serial1844001, lenses prior to 1969 usually chrome finish.
Lenses after mid 1958 in black finish

(f) Chrome finish prior to 1967
(g) Lenses until 1964 usually in chrome finish
(h) Optical design changed at serial 2656667 E55 filter from 2788927
(k) Angle of view is for full-frame (36x24mm) M8 angle of view is narrower

M RANGEFINDER CAMERAS (G)

Model	Available From-To	Lens Fitting	Rangefinder / Viewfinder	Built-In Metering	Motor (M) Winder (W)	Shutter Speeds	Comment
LEICA M3	1954-1967	Leica M bayonet standard	yes 50/90/135mm	none	no	Mechanical manual 1-1/1000	higher magnification range/viewfinder
LEICA MP	1956-1967	Leica M bayonet standard	yes 50/90/135mm	none	no	Mechanical manual 1-1/1000	
LEICA M2	1958-1967	Leica M bayonet standard	yes 35/ 50/90mm	none	no	Mechanical manual 1-1/1000	
LEICA M1	1959-1964	Leica M bayonet standard	none 35/ 50mm	none	no	Mechanical manual 1-1/1000	
LEICA MD	1963-1966	Leica M bayonet standard	none	none	no	Mechanical manual 1-1/1000	
LEICA M2Mot	1966	Leica M bayonet standard	yes 35/ 50/90mm	none	Special	Mechanical manual 1-1/1000	
LEICA M4	1967-1975	Leica M bayonet standard	yes 35/50/90/135mm	none	no	Mechanical manual 1-1/1000	
LEICA MDa	1966-1976	Leica M bayonet standard	none	none	no	Mechanical manual 1-1/1000	
LEICA M4-Mot	1968-1971	Leica M bayonet standard	yes 35/50/90/135mm	none	Special	Mechanical manual 1-1/1000	
LEICA M5	1971-1975	Leica M bayonet standard	yes 35/50/90/135mm	yes	No	Mechanical manual 1-1/1000	
LEICA CL	1973-1976	Leica M bayonet standard	yes* 40/50/90mm	yes	No	Mechanical manual 1-1/1000	* short base length unsuitable for lenses faster than f2 (50mm) or f4 (90mm)
LEICA M4-2	1978-1980	Leica M bayonet standard	yes 35/50/90/135mm	none	Winder M4-2	Mechanical manual 1-1/1000	

Model	Available From-To	Lens Fitting	Rangefinder / Viewfinder	Built-In Metering	Motor (M) Winder (W)	Shutter Speeds	Comment
LEICA MD-2	1977-1987	Leica M bayonet standard	none	none	Winder M4-2	Mechanical manual 1-1/1000	
LEICA M4-P	1981-1987	Leica M bayonet standard	yes 28/35/50 75/90/135mm	none	Winder M4-P	Mechanical manual 1-1/1000	
LEICA M6	1984-1998	Leica M bayonet standard	yes 28/35/50 75/90/135mm	yes	Winder or Motor Drive M	Mechanical manual 1-1/1000	
LEICA M6J	1994	Leica M bayonet standard	yes 35/50/90/135mm	yes	Winder or Motor Drive M	Mechanical manual 1-1/1000	limited edition M3 anniversary model with higher magnification finder (0.85x)
LEICA M6/.85	1998	Leica M bayonet standard	yes 35/50/75 90/135mm	yes	Winder or Motor Drive M	Mechanical manual 1-1/1000	higher magnification finder (0.85x)
LEICA M6TTL / 0.72	1998-2002	Leica M bayonet standard	yes 28/35/50 75/90/135mm	yes	Winder or Motor Drive M	Mechanical manual 1-1/1000	TTL flash and revised shutter speed dial
LEICA M6TTL / 0.85	1998-2002	Leica M bayonet standard	yes 35/50/75 90/135mm	yes	Winder or Motor Drive M	Mechanical manual 1-1/1000	higher magnification range/viewfinder (0.85x)
LEICA M6TTL / 0.58	2000-2002	Leica M bayonet standard	yes 28/35/50 75/90mm	yes	Winder or Motor Drive M	Mechanical manual 1-1/1000	lower magnification range/viewfinder (o.58x)
LEICA M7/0.72	2002-	Leica M bayonet standard	yes 28/35/50 75/90/135mm	yes	Winder or Motor Drive M	Electronic manual 4-1/1000 Auto 32-1000	Auto exposure, TTL flash to 1/50 sec, high speed flash 1/250-1/1000sec
LEICA M7/0.85	2002-	Leica M bayonet standard	yes 35/50/75 90/135mm	yes	Winder or Motor Drive M	Electronic manual 4-1/1000 Auto 32-1000	higher magnification range/viewfinder (0.85x)
LEICA M7/0.58	2002-	Leica M bayonet standard	yes 28/35/50 75/90mm	yes	Winder or Motor Drive M	Electronic manual 4-1/1000 Auto 32-1000	lower magnification range/viewfinder (o.58x)

continued on next page

M RANGEFINDER CAMERAS CONTINUED

Model	Available From-To	Lens Fitting	Rangefinder / Viewfinder	Built-In Metering	Motor (M) Winder (W)	Shutter Speeds	Comment
LEICA MP/0.72	2003-	Leica M bayonet standard	yes 28/35/50 75/90/135mm	yes	Winder or Motor Drive M	Mechanical manual 1-1/1000	pull-up rewind knob, basic flash synch, rangefinder improved
LEICA MP/0.85	2003-	Leica M bayonet standard	yes 35/50/75 90/135mm	yes	Winder or Motor Drive M	Mechanical manual 1-1/1000	higher magnification range/viewfinder (0.85x)
LEICA MP/0.58	2003-	Leica M bayonet standard	yes 28/35/50 75/90mm	yes	Winder or Motor Drive M	Mechanical manual 1-1/1000	lower magnification range/viewfinder (o.58x)
LEICA M8 (10.31MP digital sensor 18x27mm)	2006-	Leica M bayonet standard with 6bit coding reader	yes 24/28/35/50 75/90mm (adjusted for effective 32/37/47/67/ 100/120)	yes	built-in Winder for shutter	Electronic manual 4-1/8000 Auto 32-1000 max synch speed 1/250 sec	first digital Leica M body. Slightly reduced magnification range/ viewfinder (0.68x)
LEICA M8.2 (10.31MP digital sensor 18x27mm)	2008-	Leica M bayonet standard with 6bit coding reader	yes 24/28/35/50 75/90mm (adjusted for effective 32/37/47/67/ 100/120)	yes	built-in Winder for shutter	Electronic manual 4/1/4000 Auto 32-1000 max synch speed 1/180 sec	second digital Leica M body. Slightly reduced magnification range/ viewfinder (0.68x)

Lens		Focal Length in mm Maximum Aperture	Angle of View Degrees	Elements / Groups	Smallest Aperture	Focusing Range	Filter Size	Finish	Note	Available From-To	Code
SUPER ANGULON		21 f4	92	9/4	f22	inf-0.4m	E39	chrome		1958-1962	SUOON
HEKTOR		28 f2.8	76	5/3	f25	inf-1m	A36	chrome	(A)	1935-1953	HOOPY
SUMMARON		28 f5.6	76	6/4	f22	inf-1m	A36	chrome		1955-1963	SNOOX
ELMAR		35 f3.5	64	4/3	f18	inf-1m	A36	chrome	(A)	1931-1939	EKURZ
SUMMARON		35 f3.5	64	6/4	f22	inf-1m	A36	chrome		1950-1956	SOONC
SUMMARON		35 f3.5	64	6/4	f22	inf-1m	E39	chrome		1956-1960	SOONC
SUMMARON		35 f2.8	64	6/4	f22	inf-1m	E39	chrome		1958-1963	SUMOO
SUMMICRON		35 f2	64	8/6	f16	inf-1m	E39	chrome		1958-1963	SAWOO
ELMAX	*	50 f3.5	45	5/3	f18	inf-1m	A36	nickel		1924-1925	_
ELMAR	*	50 f3.5	45	4/3	f22	inf-1m	A36	chrome	(A)	1926-1962	ELMAR
ELMAR	*	50 f2.8	45	4/3	f22	inf-1m	E39	chrome		1957-1962	ELMOO
HEKTOR	*	50 f2.5	45	6/3	f18	inf-1m	A36	chrome	(A)	1930-1939	HEKTOR
SUMMAR	*	50 f2	45	6/4	f12.5	inf-1m	A36	chrome	(A)	1933-1940	SUMAR
SUMMITAR	*	50 f2	45	7/4	f16	inf-1m	E36	chrome		1939-1953	SOORE
SUMMICRON	*	50 f2	45	7/6	f16	inf-1m	E39	chrome		1953-1960	SOOIC
SUMMICRON		50 f2	45	7/6	f16	inf-1m	E39	chrome		1960-1962	SOSTA
XENON		50 f1.5	45	7/5	f9	inf-1m	special	chrome		1936-1949	XEMOO
SUMMARIT		50 f1.5	45	7/5	f16	inf-1m	E41	chrome		1949-1960	SOOIA
SUMMILUX		50 f1.4	45	7/5	f16	inf-1m	E43	chrome		1960-1963	SOWGE
HEKTOR		73 f1.9	34	6/3	f25	inf-1.5m	special	chrome		1932-1942	HEGRA
SUMMAREX		85 f1.5	28	7/5	16	inf-1.5m	E58	chrome	(B)	1943-1960	SOOCX
ELMAR		90 f4	27	4/3	f32	inf-1m	A36	chrome	(B)	1931-1958	ELANG
ELMAR		90 f4	27	4/3	f32	inf-1m	E39	chrome		1958-1963	ELANG
ELMAR		90 f4	27	3/3	f32	inf-1m	E39	chrome		1963-1964	11730
ELMARIT		90 f2.8	27	5/3	f22	inf-1m	E39	chrome		1959-1963	ELRIT
THAMBAR		90 f2.2	27	4/3	f25	inf-1m	E48	black		1935-1941	TOODY
SUMMICRON		90 f2	27	6/5	f22	inf-1m	E48	chrome		1957-1958	SOOZI
SUMMICRON		90 f2	27	6/5	f22	inf-1m	E48	chrome		1959-1962	SEOOF
ELMAR		105 f6.3	23	4/3	f36	inf-3m	A36	black		1932-1937	ELZEN
ELMAR		135 f4.5	18	4/3	f36	inf-1.5m	A36	black		1931-1933	EFERN
HEKTOR		135 f4.5	18	4/3	f32	inf-1.5m	A36	chrome	(B)	1933-1956	HEFAR
HEKTOR		135 f4.5	18	4/3	f32	inf-1.5m	E39	chrome		1956-1960	HEFAR
ELMAR		135 f4.0	18	4/4	f22	inf-1.5m	E39	chrome		1960-1964	11750

*Collapsible mount; see text re use on M5 and M6.

(A) Nickel finish on some early lenses
(B) Black finish on early lenses

Note that in recent years Leica have very occasionally produced small batches of current M lens designs with a screw mount, usually to special order.

VISOFLEX LENSES (I)

LENS	Note	Focal Length in mm Maximum Aperture	Angle of View Degrees	Elements / Groups	Smallest Aperture	Focusing Range	Filter Size	Finish	Available From-To	Code
ELMAR	(A) (E)	65 f3.5	36	4/3	f22	inf-0.33m	E41	chrome	1960-1969	1106
ELMAR	(A) (E)	65 f3.5	36	4/3	f22	inf-0.33m	S6	black	1969-1984	1116
HEKTOR	(B) (E)	125 f2.5	20	4/3	f22	inf-1.2m	E58	chrome	1954-1963	1103
TELE-ELMARIT	(D)	180 f2.8	14	5/3	f22	inf-1.8m	S7	black	1965	1191
TELYT	(B) (E)	200 f4.5	12	5/4	f36	inf-3m	E48	black	1935-1958	OTPL
TELYT	(B) (E)	200 f4	12	4/4	f22	inf-3m	E58	black	1959-1984	1106
TELYT	(B) (E)	280 f4.8	8.5	4/4	f22	inf-3.5m	E58	black	1961	1190
TELYT	(B) (E)	280 f4.8	8.5	4/4	f22	inf-3.5m	E58	black	1961-1970	1191
TELYT	(D) (E)	280 f4.8	8.5	4/4	f22	inf-3.5m	S7	black	1970-1984	1191
TELYT	(B)	400 f5	6	5/4	f36	inf-8m	E85	black	1936-1955	TLCC
TELYT	(B)	400 f5	6	4/3	f32	inf-8m	E85	black	1956-1966	TLCC
TELYT	(F)	400 f5.6	6	2/1	f32	inf-3.6m	S7	black	1966-1971	1186
TELYT	(D)	400 f6.8	6	2/1	f32	inf-3.6m	S7	black	1970-1984	1196
TELYT	(F)	560 f5.6	4.3	2/1	f32	inf-6.6m	S7	black	1966-1971	1186
TELYT	(D)	560 f6.8	4.3	2/1	f32	inf-6.4m	S7	black	1970-1984	1186

(A) For use with 16464 Universal focusing mount.
(B) Adapter 16466 required with Visoflex II/III.
(C) Filter fits in special filter slot.
(D) Not for use on Visoflex I or PLOOT.
(E) Lens head canbe used on Focusing Bellows
(F) For Televit

General Note 1. Many earlier 90mm and 135mm lenses have removeable lens-heads that will fit the various reflex housings and/or bellows units via special focusing mounts or adapters. Shorter focal lengths may also fit direct but only give close-up focus.

General Note 2. Lenses that either fit or have been adapted for use on Visoflex II or III can be fitted to Leicaflex and Leica R cameras via adapter 14167. Adapter 16863 allows 65/3.5 Elmars and 90/2.8 Elmarit or 135/4 Elmar lens-heads to fit Bellows R.

CURRENT LEICA M LENSES (J)

Lens	Focal Length in mm Maximum Aperture	Angle of View Degrees (diagonal) fullframe	Angle of View Degrees (diagonal) M8	Elements / Groups	Smallest Aperture	Focusing Range	Smallest Object Area in mm fullframe	Smallest Object Area in mm M8	Filter Size	Length mm	Diameter in mm	Weight gm	Code
16-18-21 TRI-ELMAR-M ASPH *	16f4	107	0	10/7	f22	inf-0.5m ##	915x1373	688x1032	E67 +	62	54	335	11642
"	18f4	100	84	10/7	f22	inf-0.5m ##	833x1250	626x939	E67 +	62	54	335	11642
"	21f4	92	75	10/7	f22	inf-0.5m ##	725x1087	545x817	E67 +	62	54	335	11642
SUMMILUX-M ASPH *	21f1.4	92	75	10/8	f16	inf-0.7m	685x1028	614x771	E82 +	77	70	582	11647
ELMARIT-M ASPH *	21f 2.8	92	75	9/7	f16	inf-0.7m	696x1044	522x783	E55	46	58	300	11135
SUMMILUX-M ASPH **	24f1.4	84	68	10/8	0	inf-0.7m	609X914	457x686	E72 +	76	73	500	11601
ELMARIT-M ASPH **	24 f 2.8	84	68	7/5	f16	inf-0.7m	630X945	473x709	E55	45	58	290	11878
ELMAR-M ASPH **	24 f 3.8	83	67	8/6	f16	inf-0.7m	624X936	468X702	E46	53.5	53	360	11648
SUMMICRON-M ASPH	28 f 2	76	60	9/6	f16	inf-0.7m	528X793	396x594	E46	41	53	270	11604
SUMMICRON-M ASPH siver anodised	28 f 2	76	60	9/6	f16	inf-0.7m	528X793	396x594	E46	41	53	270	11661
ELMARIT-M ASPH	28 f 2.8	75	60	8/6	F22	inf-0.7m	533X800	400x600	E39	30	52	180	11606
SUMMILUX-M ASPH	35 f 1.4	64	50	9/5	f16	inf-0.7m	420X630	315x473	E46	48.2	53	310	11874
SUMMICRON-M ASPH	35 f 2	64	50	6/6	f16	inf-0.7m	419x627	314x471	E39	34.5	53	255	11879
SUMMICRON-M ASPH silver chrome	35 f 2	64	50	6/6	f16	inf-0.7m	419x627	314x471	E39	34.5	53	340	11882
SUMMARIT-M	35 f2.5	63	50	6/4	f16	inf-0.8m	490X735	367x551	E39	33.9	51.4	220	11643
NOCTILUX-M ASPH	50 f0.95	47	36	8/5	f16	inf-1m	406X608	305X456	E60	75	73	630	11602
SUMMILUX-M ASPH #	50 f 1.4	47	36	8/5	f16	inf-0.7m	271X407	203x305	E46	52.5	53.5	335	11891
SUMMILUX-M ASPH # silver chrome	50 f 1.4	47	36	8/5	f16	inf-0.7m	271X407	203x305	E46	52.5	53.5	335	11892
SUMMICRON-M #	50 f 2	45	35	6/4	f16	inf-0.7m	277X416	208x312	E39	43.5	52	240	11826
SUMMARIT-M	50 f2.5	47	36	6/4	f16	inf-0.8m	338X508	254x380	E39	33	51.5	230	11644
APO-SUMMICRON-M ASPH #	75 f 2	32	24	7/5	f16	inf-0.7m	169X254	127x190	E49	66.8	58	430	11637

continued on next page

CURRENT LEICA M LENSES CONTINUED

Lens	Focal Length in mm Maximim Aperture	Angle of View Degrees (diagonal) fullframe	Angle of View Degrees (diagonal) M8	Elements / Groups	Smallest Aperture	Focusing Range	Smallest Object Area in mm fullframe	Smallest Object Area in mm M8	Filter Size	Length mm	Diameter in mm	Weight gm	Code
SUMMARIT-M	75 f2.5	32	24	6/4	f16	inf-0.9m	238X357	178x268	E46	60.5	55	345	11645
APO-SUMMICRON-M ASPH #	90 f 2	27	20	5/5	f16	inf-1m	220X330	165x247	E55	78	64	500	11884
SUMMARIT-M	90 f2.5	27	20	5/4	f16	inf-1m	213X320	160x240	E46	66.5	55	360	11646
MACRO-ELMAR-M with MACRO ADAPTER	90f4	27	20	4/4	f22	inf-0.77m 0.77-0.5m	161X241 72X108	120X180 54X81	E39	59/41***	52	320	11633
APO-TELYT-M #	135 f 3.4	18	14	5/4	f22	inf-1.5m	220X330		E49	104.7	58.5	450	11889

*** Additional viewfinder required**

(not withM8)**

***** when collapsed +special filter holder required**

Unless indicated otherwise lenses are supplied in black finish .

Note that siver-chrome finish lenses are heavier due to use of brass in the mounts.

These lenses have a built-in lenshood. Others are supplied with a separate hood (extra cost for Summarit lenses).

rangefinder focusing only to 0.7m

Bibliography

Leica M photography, practical guides

Bower, Brian	Leica M photography	(David and Charles)
Bower, Brian	The Leica Lens Book	(David and Charles)
Osterloh, Gunter	Leica M	(Lark Books)

Leica photography (general), a small selection

Cartier Bresson, Henri	The Man the Image and the World	(Thames and Hudson)
Frey, Verena	75 Years of Leica Photography	(Leica Camera A.G.)
Haas, Ernst	The Creation	(Michael Joseph)
Magnum, Various	In Our Time	(Andre Deutsch)
Salgado, Sebastiao	Workers	(Phaedon)

Leica history and collectors' guides

Lager, James	Illustrated Guides Volumes I, II, III	(Lager Limited Editions)
Laney, Denis	Leica Collectors Guide	(Hove Books)
Shinichi, Nakamura	Leica Collection	(Asahi Sonorama)

Leica specific Web Sites

Leica Camera	www.leica-camera.com/home
Leica User Forum	www.l-camera-forum.com/leica-forum
Leica Forum Hong Kong	www.hklfc.com

Leica Clubs/Societies

The Leica Fellowship (UK)	www.leica-fellowship.co.uk
The Leica Historical Society of America (LHSA)	www.lhsa.org
Leica Historica (Germany)	www.leica-historica.de
The Leica Society (UK)	www.theleicasociety.org.uk

Leica Magazine

LFI (Leica Fotografie International)	www.lfi-online.com

Index